SHORT IDEAS

SHORT IDEAS

Writing Creative for Commercial, Corporate & Online Video

by
karim zouak

Copyright © 2016 by Karim Zouak

All rights reserved. No part of this publication may be reproduced, distributed, or transmitted in any form or by any means, including photocopying, recording, or other electronic or mechanical methods, without the prior written permission of the publisher, except in the case of brief quotations embodied in critical reviews and certain other noncommercial uses permitted by copyright law. For permission requests, write to the publisher, at shortideas@karimzouak.com

www.karimzouak.com

First Edition.

To everyone who struggles to figure it out.

Contents

1	You Are Here.	1
2	Show Me Your Briefs.	5
3	Distributing A Medium–Form Genre?	17
4	Which Umbrella Are We Under?	23
5	What's The Package?	47
6	What Am I Actually Looking At?	57
7	Take It To The People!	71
8	Squeeze Your Brains.	77
9	Write It Up!	87
10	The Third Pass.	99
11	Just Make The Baby An Elephant?	105
12	You Are There.	111
&	Holding Hands With Mr Happy.	113
–	About The Author	117

1

You Are Here.
An introduction to the subject of writing creative for short format video.

Why another book for writing for the screen? Well, because there aren't any. Not for short form content, anyway. Sure, there are heaps of books on writing features, television and short films, but they don't discuss the other forms of short content or address their particular challenges.

There are a huge variety of videos that exist outside these three forms, and it's a huge business. The last decade has seen an incredible explosion for demand in video production as every brand scrambles for their own online videos, whether it's brand films, commercials, animated GIFs, product demonstrations or even setting up their own channel full of vlog-style social media content. This world of video content is expanding at a dizzying speed, but how do you learn how to create for it? Using a camera or editing software isn't necessarily complicated, but neither is using a paint brush, and we don't all run around painting frescos on our ceilings.

You can look through the advertising route, but courses, blogs and books have a vision of the copywriter as someone who can write anything for any purpose without any particular background in film or video production. Educating yourself this way involves a lot of indirect study as you consider billboards, print ads and TV commercials, which can be useful but doesn't approach the scope of videos we're dealing with. There is great value in the lessons available by mining advertising texts, but I argue that a writer dedicated to a specific medium will benefit immensely from specialist knowledge in that area. Video has so many idiosyncrasies to its development and production that I can't imagine being an effective writer without all of these hard–learned lessons to inform my choices. It is critical to writing to budget, to opportunity,

and to navigating the various challenges that crop up during a production.

The other option is that you can go to university and major in film and television, where you are encouraged to become idealistically focused on features, short films or television, spending little to no time considering other short form content. This is not ideal, either, as there are skills and concerns related to purposeful communication design, branding, marketing and client management that you are forced to learn on the job. So, without online resources, books or schools, you find yourself dependent on the luck of finding a mentor or colleague to guide you, or, in tried and true fashion, you blag it and insist for all that you are worth that you are capable and desperately try to figure it out.

When I was taken on as a writer/producer in the on–air promos department at MTV, I was in for a shock. I had already directed and edited several TV series for national broadcast so I had thankfully learned some hard lessons in storytelling in narrative, documentary, reality and variety formats, but I was not prepared when I sat down to write my first commercial pitch. Thirty seconds is nothing. Take the final 8 seconds off for the message (go to a website, buy the product, watch the movie, &c) and you are left with 22 fleeting seconds. No time for grand setup shots, atmospheric dialogue, or layers of jokes. Get to the point with your best dialogue and make it count. And there is no way to shoot everything you fancy and then sort it out later as the punishing production and delivery schedules mean that you need to shoot as little as possible, both so that you do it very well and that you can cut it together quickly. A couple of options in your pocket will be your friend, but too many and you've both rushed everything and wasted

time. I managed it after many rewrites, timing each read through and obsessing over the pacing, and accepted that this short format world was something new to be discovered.

As I've continued my career as a creative writing for short form video, I've periodically looked for what resources are available to help hone my craft, what wisdom or techniques I can take on board to help my creative development. You can stumble on an article with tips for writing a very specific genre of video, or something that considers online video to be a single style that has a single approach that can be explained in 250 words, but this is clearly not the reality, and not very helpful to the professional practitioner. Titles like "How To Write A Great YouTube Script" or "7 Killer Secrets To Writing An Online Script" are missing the point that there is not one kind of video and not one kind of script, and I would argue that the script isn't the first thing you want to do, anyway — there's a whole process you should follow before even thinking about it.

So, in the spirit of contributing to the community within which I've built my niche, I offer what knowledge and techniques I can to help other writers to improve their craft, provoke a closer critical examination of our profession, and further the attention and respect paid to this critical element of the production process.

2 Show Me Your Briefs.
An analysis of what is necessary in a brief and traps to avoid.

Jumping in head–first to writing your script — INT. MAKING IT UP AS I GO ALONG, DAY. — isn't a very good way to spend your time. Maybe you'll have some fun, or crack out some lovely LOL–inducing bants, but this is the same thing as deciding to build a house and then jabbing a two-by-four into the ground as you text your friend to come over to watch the game.

Writing the script is important but it needs to happen when the groundwork has been laid, sparing you the pain of spending vast amounts of time taking stabs in the dark. Fortunately, there's a reasonable process that can lead you to writing a script that is close to the mark and requires minor revisions rather than an entirely new concept. It begins with the brief, the originating request for this piece of content that you are going to create.

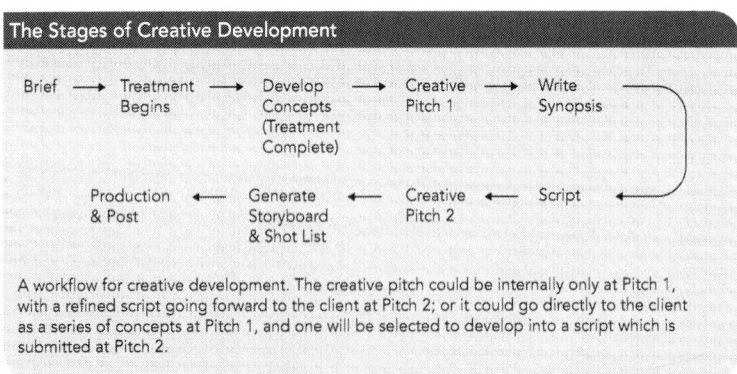

A workflow for creative development. The creative pitch could be internally only at Pitch 1, with a refined script going forward to the client at Pitch 2; or it could go directly to the client as a series of concepts at Pitch 1, and one will be selected to develop into a script which is submitted at Pitch 2.

Importance of The Brief

The cornerstone of any job is the brief. Whether it's an agency, communications firm, corporate client, or your company's own desire to create something, you need clear answers to define your starting point. This information should be clearly provided in a brief.

The brief defines the creative and technical scope of the job. It is the guiding light that helps keep you on track, providing the founding principles to which you will test your creative project through its journey to completion. Without this document, you will not be able to justify that your creative concept is a good response to the job. And if you do manage to squeak past the pitch without a proper test of the idea, you may find yourself in a dangerous scenario, not realising that you have gone off track until it is much too late. Or you may find yourself facing a client who has changed their mind about some important criteria.

The brief offers an agreement of the terms of the project, like a contract. Remember, a "great idea" is a great idea only if it fits the project, otherwise you've got a bomb on your hands just waiting to go off — someone will eventually figure out that this idea doesn't fit, no matter how fun, clever, trendy or other seductive quality that makes you love it.

The Brief in Detail
Ideally, you're writing in the context of a regular advertising/marketing process and someone has prepared a brief that outlines the critical points, detailing the product or service, the strategy, the final output and any contextual information that helps you find a creative idea that fits the purpose.

At a minimum, a good brief should contain:

1. The objective of the video
2. The target audience
3. Tone
4. Background of the product, participants or other key elements

5. Deliverables (ie. the quantity and duration of videos to be delivered)
6. Budget range
7. Timelines
8. Distribution
9. Any mandatories (ie. things that must or must not be included in the video).

Sample Brief

Agency Name

Project: Brand X Widgets
Client: Brand X

Document Version: 1
Date: xx/xx/xxxx

Objective:
To launch Brand X Widgets to market.

Target Audience:
Fathers aged 35–50.

Tone:
Light-hearted, playful, colourful, inclusive. See original campaign for reference.

Product Background:
After a succesful launch in the UK, Brand X is bringing their market-leading widgets to North America. They have been designed for portability and low cost, winning numerous design and environmental awards.

The UK strategy proved very successful, with strong audience engagement and retention of brand/product information. This current campaign will build upon the creative and strategic direction of the original, versioning it for the local market.

Deliverables:
(1x) 60 second video
(2x) 15 second cut downs for social media

Budget:
£10,000 — £15,000

Timelines:
Delivery by August 15. Product packaging is only available as of August 6.

Distribution:
YouTube for the 60 second video, and Twitter, Facebook and Instagram for 15 second versions.

Mandatories:
Host (TBD by July 25) to be a relevant local blogger.

Unfortunately for many of us, writing for online is outside of the traditional order because of the massive

proliferation of demand for content creation and the speed of getting it done. People often don't know what they want, what they're asking for, why, or how to ask, and you are put in the position of making content that is vague or tangential to an existing (and undisclosed) campaign. They just want it done. So rather than say no to business, you need to carry on and figure it out by building your own brief.

Building A Brief

When a client sends over a thorough and complete brief, it's a bit like Christmas. You know they know how this works, and you know they appreciate the importance of all of this information so that you can do your best work for them.

Unfortunately, this isn't always the case and you may need to cobble the information together yourself via meetings or conference calls. I encourage you to be absolutely persistent in getting the answers that you need to be able to do the job, and not go on assumptions of what the client may likely want as this can lead you way off course, either wasting your time or embarrassing you in front of the client. Develop your relationship so that you can check with them to clarify any points you don't understand — this is part of helping each other to do a great job.

You really need to pin down the clearest answers that you can get, as these are the foundation upon which all of your writing will be built. You will test your ideas against these assumptions, and corrective action later in the process can be extremely disruptive to the integrity of your script. Revisions often seem like trivial changes to make, but if not carefully considered they could easily unravel the

coherence of the video. Maybe they won't, and you can accommodate any changes that come up, but that is a lucky scenario. Why test your chances? The answers need to be as clear and specific as possible. They will form the basis of your brief — the basis of everything — so they must be useful and articulate.

The answers you need can be elicited by three critical questions:

1. What is the objective of the film?
2. Who is the audience?
3. When are the key dates?

Without this basic information, which can be surprisingly difficult to pin down, you are taking wild stabs in the dark.

"What is the objective of the film?" identifies the purpose of the film. What are we trying to say and why are we saying it? What message should the viewer have received by the time it is finished? In traditional television commercials, this will often be to buy a product. So you could have an objective like, "To announce the launch of our new toaster, now available at Argos." Or a brand film for a bank could want "to convince the viewer that Friendly Bank is highly engaged with individual customers".

A good objective is clear and understandable, with only one thing it is trying to accomplish. Content is generally quite short, and the motion image more an emotive than logical medium, so conveying multiple messages can be extremely complex and is generally a bad idea. Some clients have a laundry list, so you can attempt a short, secondary message, but I would strongly discourage you

from taking on more than that. I wouldn't.

If the answer to this question doesn't have an implicit answer to "why are we doing this", then that needs to be prompted. The *why* digs at the strategy or reasoning behind the objective. "To announce the launch of our new toaster" suggests that the *what* is "to inform the audience that a new toaster is coming to market" and the *why* is "because we have created a new product". The brand film example wants to convince the viewer that Friendly Bank has great customer engagement but the *why* is unclear. It may be "to own the customer service space because our competitors dominate in number of branches and ROI." This strategic context can have a critical influence on the direction of your creative ideas, so it is best to clarify this if possible.

"Who is the audience?" is the next critical part of the equation, as in "who am I talking to?" Young single moms? Teenage boys? People working two jobs? Retirees? Each of these groups gives you an entry point into imagining what they might find engaging and how you might speak to them. If I told you that the video was for "anybody and everybody", you would find yourself in a much more difficult spot. The result would probably be less than inspiring, unable to take a step in any particular direction as you are trying to always satisfy all parties. If there are secondary audiences that you don't want to alienate, then you can write with consideration to give them a point of emotional access, but you have at least established a starting point of to whom you are trying to speak.

Finally, it is critical to know key dates. If you have to shoot tomorrow or deliver by the end of the week, you will need to accommodate that in your creative.

A traditional advertising perspective would also incorporate "what is the benefit?" as a critical follow-up to these questions, as it clarifies the particular approach that will be taken in communicating the objective to the audience, but outside of the strict commercial sphere I find that it is both difficult to apply this helpfully to other genres of video and clients are unlikely to have developed this level of strategic preparation. As a creative, you will propose a benefit within the context of the concepts that you put forward, and this should be guided by the strategy elicited from the *why* portion of the objective.

If necessary, follow your instincts and challenge the veracity of the answers you get. Test and interpret what you've been given in new words. Sometimes people mistakenly don't mean what they say, especially when talking about something out of their usual world. Beware phrases like, "we want something really out of the box". People who think outside of the box don't really use phrases like this. You may write something a little crazy and then revise it, revise it, revise it, and revise it until it's a bog standard, cookie-cutter piece of work, and nobody likes making cookies in a bog. Not pretty. Sometimes you will need to go through this routine, but sometimes you can get a feel for them not wanting what they say they want and just cut to it quickly. Try creative techniques like having them respond to a series of reference films that may help clarify the situation. In the end, they'll be thrilled that you pegged them "just right" and everybody is happier.

Field Notes
I went through this once on a radio spot to promote a TV series. Radio has certain restrictions of form, given there is only sound to tell the story, and with my background in experimental film in tow I tried to offer up some great "out

of the box" ideas. I naïvely took this request at it's word when what they were really after was a well executed version of the very strict form that they usually do. Sometimes it's not what they say but it is what they mean, and it is what you'll end up doing in the end, whether you like it or not. Now I often have a quite conventional idea that I think is a good execution of the traditional form to present alongside the requested OOTB idea. This approach has other challenges, but we'll discuss that later.

The other criteria described above are also very important, as they may or may not have an impact on your particular project. It is best to clarify them before heading into generating the creative ideas that will eventually lead to a script, but you can often wing it with just these few.

Going Without A Brief
This is a hard lesson to learn. Every time I have accepted to "just write something" without getting clarity on the necessary specifics, I've eventually had to scrap the work and restart. This in itself isn't the problem. The incumbent demoralisation of wasting time takes a toll, but if your company tracks hours against a project then you face increased pressure due to the lost job hours.

It's horrifying to meet with the client and realise before you present your work that you've gone way off track due to a lack of information or bad assumptions. Even if you're unlucky enough to sail past these early revelations of being off track, it will still hit the project at some point, and the later it is the worse it will be. It's not pretty to show a client your first edit and they ask you basic questions that you can't answer, like who the audience is, and you have nothing to say but a whole mess of waffle. It doesn't matter that you were begging for the answer to that question

earlier, because it's now your problem. You went ahead anyway and now you have to own the mess.

Client–Generated Creative

Sometimes, the client will insist that they write the script. Welcome to the danger zone. It is possible that somebody has changed career and joined your client's profession, or is an amazing amateur filmmaker. I hope that this is the case and you've been given a fantastic script. But odds are that they aren't, so expect to have to decode and re–write it. With luck, it's in reasonable shape and you can see the structure they're after, so using their script as a guide you should be able to do a revisionary pass and make some necessary adjustments.

If it isn't, you may have an unspecified number of egos to navigate if it was written by committee. If you're dealing with a large corporation, it has definitely been across a lot of desks for approval, and anyone may have worded a particular passage. Or maybe the contact person that you're dealing with, though an unlikely candidate, has been tasked with writing it and did they best they could. They don't need to feel bad about it and you definitely don't need to alienate this person with undue judgement. Good thing that you're here to help.

You need to champion how fantastic the script is in identifying all of the key points and imagery that chart out the territory the film needs to cover, and recommend that you take a pass at a revision that helps it fit the form a little better. Then if you go through it line by line you should be able to deconstruct the messages that they are trying to express and you can rewrite it in a form that flows better.

Sometimes, people just want a lookalike but are shy to

come out with it. They want you to just take video X and remake it with their product instead. What can I say? This is hardly thrilling creative, and depending on the scenario could be copyright infringement. But it can happen, and despite "loving the exciting ideas" you present, they clearly just want a recreation of something extant. Here lies a crossroads of deciding what kind of business you are in — are you a service that does whatever a client wants or creative specialists that make original material? Or somewhere in between? It's a very tough situation and there is no clear answer.

Another difficult request is for a viral video, as this is a circumstance not a style. If this is the case, consult with an ad tech company like Unruly Media or Virool and they'll give you some support. The old idea that a short, funny video with a celebrity and a pet guarantees that it will get watched is not supported by the data. Moments of authenticity and originality with a solid distribution plan have a much better chance of succeeding, but nothing is guaranteed. Part of the budget definitely needs to be allocated to clever distribution, and the client needs to put their faith in something bold and unexpected that is in the right relationship to their brand positioning and social media use at that moment. But this starts going down the road of strategy, not writing, so we'll stop here.

Finally, brief in hand and poised to generate your creative, it's time for one last check. Suss out if anybody along the line is already hooked on a certain idea. People can often be enamoured with a perfume video (or similar) that they saw somewhere and want to take inspiration from it, and somebody who is important enough in the chain needs to be listened to, regardless of how good the particular idea is. These hurdles can be bent into a better

shape, but sometimes not entirely broken. The upside is that if you bend it just right then you'll have a lot of buy-in to the idea. But first, let's sort out a few key terms — genre, format, medium and distribution method.

3 Distributing A Medium–Form Genre?
A discussion of the essentials. The differences between method of distribution, medium, form and genre.

Short Format videos can exhibit all kinds of characteristics, styles and functions, so it is worthwhile considering how these group together and relate to one another. We are considering all video that is created for commercial reasons that is not a feature film, a short film or a television episode. These three follow different market processes and have burdens of character and act structure that don't apply in the same way to the shorter format material with which we're dealing. This doesn't confine us to "online video", as there are various ways to watch or encounter a video, whether it's a stand–alone kiosk in a train station or activated on your phone as an augmented reality overlay on your camera viewer by geocache. (Current use of augmented reality as made famous by Pokemon Go, while technically employing motion images, remains part of a larger piece — a game — and therefore outside of our parameters.) So with our criteria set, let's begin.

What sets a distribution method apart from a medium? How is a form not a genre? Let's look at these key terms — distribution method, medium, form and genre — to define them and identify examples of each.

A *distribution method* is how and where something will be seen. It can dictate certain experiential parameters — like duration, frame size or whether these is audio — but otherwise makes no impact on the genre or form of what is presented. Each method has multiple channels that can have their own further implications. Key methods of distribution are:

1. Online Hosted
2. Online Live–Streaming
3. Location–Based Offline

For *online hosted*, examples are YouTube, Vimeo, Instagram and Facebook. *Online live–streaming* means Periscope, Livestream, Snapchat, Facebook Live, or some other service that does an immediate broadcast from a camera via the internet. *Location–Based Offline* refers to in–store displays, public transit screens, digital billboards and other monitors that are fixed in a physical place and their content cannot be accessed remotely by the public.

A *genre* is the big–picture style of the film, with implications of purpose and creative treatment but no implication on how the delivery is manifest or delivered. (An advertisement is still an advertisement regardless of whether it's a Super Bowl broadcast spot or if it's a silent, square video on Instagram.) An individual video that you are writing will stick to one genre, but if you are writing a campaign of multiple videos you could employ different genres to accomplish different aspects of the campaign. Many have sub–categories that we'll examine later, and sometimes you can have one masquerading as another, like a commercial that behaves like a training video, but these would still belong in one genre with the secondary one as a stylistic choice. Here are the key types of genre and a common generic objective for each:

1. Commercial — to sell
2. Promo — to raise awareness
3. Public Service Announcement — public education
4. Event — to document
5. Training — to educate
6. Branded Content — affect market perception
7. Brand Film — establish market perception
8. Internal Communications — to inform staff
9. Review — to educate
10. Factual — to inform

11. Music Videos — to sell

The *form* is the overall presentation of the video. Is the objective of the genre achieved by a narrative script or an interview? Is the training video done by someone speaking to camera (direct address) or by animation? This is the second–level creative direction of the video, and as you come up with multiple ideas to fit your objective you may choose different forms that are applied to your genre to explore different ways of engaging your audience. Think of *form* as the general style of communication of the piece, typified by:

1. Live–Action Narrative
2. Interview—Based
3. Direct address
4. Observational
5. Animation
6. Abstraction

The *medium* is the package in which the content is conveyed to the viewer. This is usually a regular video, but it can take other forms as well, such as a looping video or a GIF, both of which have important implications that can affect your writing. A looping video may be a seamless loop, which requires some careful consideration of how it is accomplished. It can be very difficult to loop a scenario with a lot of elements in motion, so you may be better off writing something intimate and controlled — less a wide shot of the city with a moving camera, more an actor against a brick wall. Similarly, Animated GIFs which loop by definition, are silent and strain against duration — the longer a GIF, the higher the file size, which puts pressure on reducing image quality and frame size. The looping videos don't face these same restraints, but can't be

distributed in all of the same places as GIFs.

A further complication is that since the same source material can be distributed across multiple channels (or subcategories of methods of distribution), it may require a different medium to sit on each one. This means that one channel (say Instagram) may happily display a looping video but another may not, which might require the actual content of the video to be repeated several times within the file. While this proliferation of versions may not affect your creative, it's always better to know what delivery is expected early on so that you can determine whether there are things that affect your idea selection, and you don't end up being surprised that audio will not be part of the final piece. The types of medium we can identify are:

1. Standard Video
2. Animated GIFs
3. 360° VR video

As you consider these categories, you can see that any given video has a genre, form, medium and method of distribution before we even get into the particular creative concept or visual style employed.

We will explore all of these in much greater detail to pick apart the challenges and expectations implicit in each area, but for now let us agree that *genre* asks the question "what is it's function?", the *form* asks "how is it communicated?", the *medium* asks "how is it packaged?", and the *method of distribution* asks "how does it get to the audience?"

Short Ideas.

4
Which Umbrella Are We Under?
Dividing the numerous forms of video into the essential genre categories.

Just as there are endless styles of feature film or television series, there are a great many different types of video that you can encounter out in the world. Not to be confused with the format, the medium or the distribution method, the genre reflects the overall purpose and context of the video. Is it a traditional commercial? Or catwalk footage for in–store display in a major department store?

Once you know your primary objective and audience, you should be able to pick an appropriate genre to communicate the message to your audience. These can be reduced to 11 essential categories that should fit most that you will encounter, with many conceivable variations on each—

1. Commercial
2. Promo
3. Public Service Announcement
4. Event
5. Training
6. Branded Content
7. Brand Film
8. Internal Communications
9. Review
10. Factual
11. Music Videos

As we discussed briefly in the previous chapter, each of these has a few objectives to which it is particularly well suited, whether by structure or tradition, and you can use this to your advantage. Your audience will have preconceptions about the form that will activate subconsciously once they recognise it. You can play according to convention, making them feel comfortable and employing a creative shorthand for needed expediency, or

you can go against convention, enhancing the emotive value of the work. Once they realise what you're doing, it will be funnier or more profound than it would have been if you stuck to convention.

An excellent example of subverting the genre is Dare's "Camp Okutta" campaign for War Child, which looks like a low–budget Product/Service Announcement but is running against the traditional objective of trying to sell something. It's using the objective of a PSA to bring attention to a social issue but not it's form, so it is in fact masquerading as a commercial to impactful effect.

Commercial

The classic TV commercial is a product or service advertisement distributed over television broadcast, and the form remains intact despite the proliferation of distribution methods. Online videos don't need to be 30 seconds exactly, but it is a comfortable format and often clients like to reserve the possibility of putting the video on a traditional broadcast, so you may find yourself working in this style with the regular constraints. Or it could be distributed without audio on public transit, where the technical requirements, duration and sound options are different but the style remains consistent — you are focused on selling the product in a memorable and favourable way.

Beware of potential :5, :10 and :15 versions for on–air, and :60 seconds for online, as it's best to consider these lengths at the script stage not the editing stage. You never know when an additional shot or line of dialogue can help stitch it together nicely.

What makes a good commercial is a huge topic covered

very well in advertising–focused books like *The Advertising Concept Book* by Pete Barry, but in brief let's discuss a few things to consider. Are you trying to convey the use of the product (eg. this product makes smoothies) or it's implication or benefit (eg. this product will make your family healthier)?

Often, you will associate a lifestyle or relatable context to a product to help the viewer feel like it is something that is (or could be) familiar to them, it is achievable to have this product. It is also common to assign a positive or aspirational effect to the product or service, and clients can be skittish if they perceive that you are "going negative" in any way. Frustratingly, this perception of negativity can be sensitive to the point of simply acknowledging that your product does something that others do not is being negative towards the competition, even if you're not saying anything about those other products. A detergent manufacturer, for example, may balk if you say that their product gets clothes the brightest because you're suggesting that other products don't. It can be infuriating, but something that can be avoided by developing a proper brief before getting started on your creative.

When writing a commercial, I find it essential to find a theme, tag line and title to give the spot internal coherence. This central idea helps you decide what the characters or location should be like, what the overall tone and message should be, and guides the writing. The final tag line and title are an expression of the theme, and if these aren't coming together then it's usually a signal that something isn't working in the commercial. I would be very cautious about putting this tag line forward to the client, however, as they often already have one in mind or late in the game decide to coordinate across a larger campaign, so make

sure that your commercial works without it.

Promo
In Two Weeks! Next Week! Thursday! Tomorrow! Tonight! Up Next! Any bit of content can use a promo, and this stems from broadcast where you want your captive audience to know about something else on your channel, such as that a new series is coming, something is returning, or something special is happening on the next episode of the show you're watching now. These are commonly 5, 10, 15 or 30 seconds but can be of any length. There is also the 'variable length' promo which means you front–load the message and then let the promo run long so that it can be aired to fill an unusual time gap, and then the switchboard can end it whenever they need. Once the initial message is delivered (coming up next!) then a montage or bits of scenes can play to fill out a minute.

Online series are no different, and promos can be used as stand–alone videos (like a trailer) or as embedded ads in other videos to let people know that a new season of an existing series is coming back. The traditional promo strategies may not apply quite so well here, as in broadcast the same promo would have various versions with different graphics and voice–over that say "next week", the day of the week, "tomorrow", "tonight" and "up next", each version tailored to the particular time slot that the promo would be airing. Broadcasters can now accomplish this with metadata updates in their on–air graphics systems, but the concept remains the same and requires custom V/O for each version. Online promos are a little different in message, as days and times are less relevant, but the strategy is sound.

A good promo will make the viewer want to watch the

show, but while it should reflect the character of the show it does not have to accurately reflect what the show contains. You are trying to stimulate interest by presenting a question or showing strong reactions to suggest that the episode is compelling. A promo for a drama, for example, may imply that the killer is going to strike again (even though he doesn't) and therefore you should not miss it, but so long as you don't explicitly lie about the contents of the show then you're in good standing. Your job is elevate interest and get people to watch the show.

Promos can vary widely in terms of content, from the traditional clip–based excerpts of the episode in question to an original script and shoot. Depending on the availability of assets, you may have no choice but to go and shoot something original, or may decide that this is the best way of building anticipation. This effectively teases the content of the show itself, and could be anything from street–style sound bites with the public to atmospheric moments of what could be sets from the show.

Field Notes

When I had first been assigned a regular weekly show promo at MTV, I had imagined that I would dutifully watch the show and then pick out the most amazing bits and string them together with a strong V/O that set up the week's episode. This may well happen in some idyllic channel somewhere, but the reality was far less compelling.

Typically, a day or two before the promo was to go to air, I would receive a download link and fetch the assets — someone else's 30–second promo from another market. Ideally, you should at least get audio stems (dialogue, effects and music on different audio tracks) and picture

without any graphics, so that you can add your own. Invariably, the audio was all mixed in together and the graphics were baked–in. Still desperate to find somewhere to contribute, I would re–write the existing order of shots to make the best :30 and :15 second promos that I could. This resulted in background music jumping around out of synch, which required me to add even stronger music over top, as well as graphics to cover the original graphics (eg. covering "Tonight at 9" with "Tomorrow at 9:30").

Eventually, I learned to accept that this wasn't the place to re–invent the wheel. In this unfortunate scenario, just cut off the end of the material you've been given and replace the old message with your new messaging of "Tonight at 9:30", "Next Week at 9:30", &c, for however many versions that you need, and trust that the previous writer/editor did a reasonable job. Sometimes doing your best to make something better just makes it worse.

A *teaser* is a form of promo that is generally purposefully light on details in an attempt to try to cultivate interest in advance of a full campaign launch. We see this often with movie trailers, where a teaser trailer will be released months before the official trailer and serves as a sort of promo for a promo. In these early stages, there is often no final footage available to be used in the spot, resulting in trailers like close shots of a Batman logo and then a final shot with the text "Summer 2020" underneath. Like any promo, it's important to be very clear on the objective and the audience, as a concise and brief message means you need exceptional clarity as to what you're trying to accomplish.

Public Service Announcement

Public Services Announcements, or Public Information

Films in the UK, are traditionally commercial-length messages created to communicate a message of social benefit or interest to the public. These can encourage certain social behaviour, like "don't text and drive", or inform the public about the existence of a charity that specialises in helping people in a particular situation. Broadcasters donate the air time, production companies may donate what resources they have, and individual participants in the production may be pressured to work for free or at a reduced rate.

As the writer, you may find yourself treading in deeply worn territory, or maybe poorly positioned out of your area of expertise. Research what they have done before to get a sense of what tone has been acceptable in the past, listen for the language that is used, and watch for possible sensitivities to larger issues. If they've previously done PSAs, then they may be in a position of updating and refreshing the message, in which case you need to ask yourself how you can address their issue while showing a slightly different perspective, or maybe you can spot a subtle distinction that can be exploited to breathe new life into the conversation.

A children's support line charity I worked with wanted to repeat their usual message but was uncomfortable with the way their clients (ie. the children) were characterised as being of a certain age, clique or social class. I seized on this distinction and conceived of a spot that suggested both the variety of users and reinforced their anonymity, breathing enough fresh life into the campaign for a consistency of message without feeling stale.

Field Notes

I was once tasked with creating the annual Black History Month promo for a national broadcaster, and was a little uncomfortable with the challenge. I have mixed Arab–Anglo heritage and I don't know the black experience. I have consumed questionable perceptions through school and the media, and I wouldn't presume to express my opinion or its validity to a community to which I don't belong. My white boss, and his white boss, didn't have the slightest concern. So, either I'm overly sensitive or unnecessarily cautious, but I was saddled with the job.

I watched the previous few years' promos, and found them often to be some variation of a clichéd salute to titans of black culture — like snippets of Martin Luther King's "I Have A Dream" speech with African tribal–themed visuals and a Louis Armstrong jazz sound bed. It delivers the message "it's Black History Month" but hardly compels you to any sort of action. So I picked this as my entry point and decided the message should be, "inform yourself about Black History", using comedy as a device to get noticed. I enlisted the help of a comedy writer used to working with racially–charged comedy and wrote a series of one–liners that skirt historical and cultural elements but ultimately confuse them with something else. A series of interview clips with people of both genders and different races showed people saying things like:

> INTERVIEWEE 1
> …Malcolm Ten. [he is corrected by an off–camera speaker] X? His name is 'Xalcolm'?!

INTERVIEWEE 2
The Black Panthers? Didn't they win
the Super Bowl in '76 *and* '77?

Most people understood that the humour was good–natured, suggesting that we all forget the details over time, and it would be great to honour the spirit of this month and brush up on the details a bit. Amazingly, the only complaint that was received by the telecommunications regulator was that the PSA had been "racist towards white people". One of the actors told me that some people had questioned him on the production of the PSA, which ran for several years. Invariably, he told them, "it's cool, the writer is from Africa" and they relaxed. Not the same part, really, but nobody ever asked.

Event

Event–based videos are commonly a document of a moderated panel or a product launch. The former doesn't offer much room for writing, as the camera crew and editor will largely be "following the puck", but you may want to consider what context needs to be established in an opening sequence. What sorts of thing do you want to convey? "People arrive" at a "busy event" and are "eagerly taking notes"? If considered in advance, this opening montage could set up the event as very important and well attended, and is a much stronger position than just showing and shooting what you happen to notice. Similarly, you can brainstorm what might be a good conclusion and any good extra pieces if other activities will be taking place.

An event–based video may require more structure, but these are often frustratingly lacking in advance detail. Clients are often scrambling to pull these together, and getting a detailed walkthrough of how the event will

unfold, what you may are may not do, and getting access to the location in advance are all unfortunately unlikely things to happen. Odds are you'll have to imagine what could happen, describe how you might shoot it, and hope that the shooting team can extrapolate an appropriate shot–list when they arrive and cobble the planned story together. In this case, it's helpful to focus on the mood and tone of what should be shot so that the subtext is clear, and suggesting specific shots that would help categorise the event in best light.

The best case for preparation for these films is a well thought–out treatment, with a clear objective, tone and concept, and a script only written as a loose guide of how the film should unfold but leaving plenty of room for interpretation when the crew encounters reality, if it's even written at all.

Training
On the face of it, training and tutorial videos are the most functionally–based of all the genres, but don't forget their use as a sales and marketing tool. Clients love to show these as both a user–friendly, benevolent feature as well as an additional, subscription–based bolt on to the original cost. The level of detail in the video has a massive impact on the possible treatment and use of language, so as ever it remains absolutely critical to know the specific objective of the film and it's audience. The assumptions of the audience will play heavily, as an audience educated in the subject matter will want you to move briskly through familiar concepts while a general audience will need extensive hand holding.

Training videos are one of the few instances where it may be wise to delve into a limited version of the actual

script before the concept is developed. Clients often have a truckload of jargon that you'll need to sift through, as well as a specialty with which you may not be familiar, so it is very important to make sure that you are understanding one another before going too far. Breaking the script down into stages, you can first assemble all of the information into one place and give it a logical flow to confirm that you've identified the correct scope and depth of the material. This usually involves a lot of reorganisation, and won't be a pretty read, but is a critical step to establish so that you're not wasting lots of time revising and rewording dialogue that is ultimately not contributing to the video. Once this is approved, then you can go in and rewrite everything so that there is a more readable flow that doesn't sound like a marketing person or engineer wrote it. As you do this, the rhythm of the piece will become apparent and you'll be able to see the areas that need clarification or visual support to be understood. This Frankenstein script serves as an agreement of what needs to be covered, and you can now go back to the concept stage and determine how best to treat this information. Review some concepts with the client, and then you can come back and revise the script to fit the concept.

On very complex jobs of extensive training on a specialty subject, it is definitely worth the time to undergo the client's training if you can. These videos are often conceived as substitutes for sending a physical trainer, so attending the training yourself will help in several ways. You'll understand the subject matter with enough competence to guide you through writing, and you'll likely yield an agenda or training order that can serve as a backbone structure to your series of videos. In the past, I have recorded these lengthy training sessions and had them transcribed, which served as an excellent basis for writing

out the scripts. The job then became about editing down and clarifying the base text, but the depth, scope and accuracy of the script were at a fantastic starting point.

A notable subset of training and tutorial videos is the *product video*, a style of video largely aimed at people researching a particular product's features and considered a decision–maker in the path to purchase. I often approach these by considering how the product is used and writing a loose story that depicts that function. Research into the market material will likely yield a laundry list of all of the features that the client wants featured, and will probably need some further research to understand. ("Why is 40 PSI of steam on an iron a good thing? Is that a lot?!") The most useful approach is to then group the features together in terms of areas of the product (front, back, top) or stages of using the product (before you plug it in, while you're using it, when you're wrapping it up). This helps economise dialogue so that you're focused on the features and less about orienting the viewer. It can also allow for tidier graphics, as you can point out a few features in the same area at the same time.

Branded Content

This is the classic "online video" that people think of, and that advertisers can't get enough of. It looks like an amusing or helpful video, but it's really some branded content — content that a brand has paid for. Cue food recipes that go great with Brand X crackers, and Extreme Sports videos of athletes doing something goofy (brought to you by GoPro). This is perhaps the most fun to write for as it's often the least restrictive, and largely depends on your client's brand and appetite for courageous content. Ideally, you can make a really nice bit of entertainment that speaks directly to your audience and employs a very soft

sell approach of delivering a branded message at the end, serving only as a commercial in so far as the brand identifies itself. The aim here is aligning the brand to the content, creating the association in the viewer's mind that the brand shares the values and feelings that you experienced in the content.

An important subset is *brand partnership* video, which features two different brands coming together for a piece of content. These were a big focus for our team at MTV where, for example, Sony might want to promote a new phone. They would buy a packaged media buy with the parent network, receive a co–branded website, some original content or contest, an on–air promo to tell viewers to go to the website, and the air time to broadcast the promo. This could be aligned to a specific show or the channel in general. The idea is basically to present Brand 1 beside Brand 2 to convince the audience that Brand 1 is similar to Brand 2, and that you should feel the same about it. In this example, it gives Sony access to the MTV audience with the reassurance that MTV approves of Sony. This was a great space to be in as a writer, as we could assure the client that we knew the audience and anything that we thought smacked of heavy branding or corporate style was "off brand" to us, with the implication that our audience would smell it out and react poorly.

Another subset is *promotional awareness*, which is a variety that shows off the good deeds that a brand is doing, like an insurance company that is running an educational program. They want to create some content that is in the domain of their activity and feature the brand alongside it, essentially boasting about charitable work. There could be celebrities attached, and they'll want to feature them somehow engaged in the context of the program.

Brand Film

Brand Films are generally a higher–end budget film where a client is trying to define their brand characteristics to the viewer rather than feature a specific product. A good starting point is getting your hands on whatever brand guidelines they have.

Hopefully, the company has already thought through all of this stuff and this film is part of a cohesive marketing plan, though of course not necessarily. It could be someone's vanity project. Whatever material you can find will suggest their brand values, how they distinguish themselves from the competition, and what sort of person they target for a customer.

Unfortunately, I've seen a lot of brand literature that is brutally cliché, ironically claiming how the brand is for outgoing, adventurous types that cut against the grain, live life to the fullest, and are embodiments of "maverickness" when in fact the material is so banal that you could black out the brand name and you'd have a hard time figuring out if it was a booze or dishwasher manufacturer. In this situation, I'd start back-tracking from this type they've described and think instead about who perceives themselves according to this fantasy, and then hopefully find some footing there. If you are stuck with painful clichés, maybe they can at least be presented in a fresh way or the film can be structured with strong technique.

Idents form a subset here. Broadcasters are legally required to air short station identification videos which are typically more branded than informative because the core message is simply "this is Channel 6". These often form a cornerstone of the on–air identity of the channel, showing off it's production ambition and sensibility, and can double

as promo opportunities as the broadcaster uses the air time to announce upcoming shows. They generally give great insight into the kind of content the channel shows and how regular viewers of the channel want to see themselves, identifying both the character of the channel and the viewer. Websites like theident.gallery are a great place to familiarise yourself with various campaigns, like the invariably stunning Channel 4 idents.

Internal Communications

Larger companies need videos created for all kinds of internal communications, whether it's a CEO delivering an annual "state of the union" speech, HR updating staff on best practices, or a departmental presentation. These often feature a lot of talking heads, stock video and whiz–bang graphics. There can also be a lot of resistance to an actual script being written. Scripts can be complicated because non–industry clients rarely know how to read them, and the internal approvals they have to go through can be a real blockage for time, yielding copious and conflicting notes. Hopefully, you can identify a point person with integrity that will take care of their end, provide the information that you need, and stick to approval commitments.

As with training films, internal communications can be complicated because you are dealing with a specialised audience with extraordinary knowledge in a key area. Since you're not a specialist, you'll likely be fed jargon and acronyms that bring the dialogue to that special place where sound is happening but communication isn't, so bring your decoder ring and do your best to sort it out. This is where clarity of audience is key. You can encourage rewording anything a general audience wouldn't understand and skipping anything that a specialised audience should.

Some clients insist that a video is for two conflicting purposes, like internal and external use, and these can sometimes be reconciled by identifying a few key passages that have multiple versions, one for each audience, but you'll have a hard time identifying that without a script. If they'll be reading from a teleprompter or memorised passages, then you're in good shape. In the event that the talking heads are "unscripted", you can at least write out a mock version that is as close as you can manage to what they will say. For either case, you'll now be able to identify what the different passages might be like and which ones may need alternate versions. You may face significant resistance to putting a script together, but your clients don't understand production — you do. Even the latter, vague version, provides clarity of where alternate lines would be helpful and where breaks in the action might take place, so that you can plan b-roll and graphics, and know where the subject can stop instead of needing to get one long, perfect take. Any opportunity to reduce the scope of what production is trying to accomplish is a massive help towards getting it done well and quickly.

I've also encountered the "have everyone say everything and sort it out later" approach, which I am not a fan of — it's often way more productive to focus on having a particular person say what they are best positioned to say, rather than aim for the whole thing to be just "passable". As always, it's best to sort out as much as possible as early as you can, as it is critical to spotting changes that should be made and focusing on doing each part to maximum effect.

Whenever you are working with corporate clients from another industry, whether it's for internal comms or a brand film, be wary of eleventh hour additional text, and have

some additional b-roll or graphic imagery in your back pocket if you can.

A subset of this style is the *pitch* film, where a corporate client is using the video medium to make a sales pitch. This lets them get a perfect take, employ graphics, and include staff that may otherwise have difficulty attending. I recommend that you try and get ahead of the story, find out what they're going to stay, and think through what the graphics could be in advance — this will let the director isolate which pieces need to be continuous and which can be cobbled together in editing from stilted or awkward takes.

Review

Review videos are anything where a subject is speaking directly to camera as themselves. The feel here is that the person is speaking authentically to the audience, and there are usually stylistic trappings that should be observed, whether it's in the "rant" style of a speaker doing a walk-and-talk with an obediently following camera, or a self-shot vlog.

If you are writing for an existing property, it can be tricky to get the feel for the voice and character of the style, but watching a few examples should give you the rhythm for it.

If you're working with an existing talent on something outside of their own series, then I'd consider very carefully how much the new piece would benefit from belonging to their usual world of videos or looking and feeling completely different. You may want to try to keep things as familiar as possible without making any "improvements" to elevate the production value, because their audience will

instinctively know what's authentic and what isn't, and if it isn't you'll put them off.

Of course, you can deviate from this for effect, which can be great so long as that's a conscious choice — some audiences would be happy to see the host in a different style of video as they'll be excited for their "friend" to move into new territory. So be clear on who is your audience, so that you can determine if you are appealing to the existing one, introducing your host to a new one, or trying to do something somewhere in–between.

After the voice, the easiest thing to lose in these videos is the plot. A strong video should still have a beginning, middle and ending to it, not just cease to continue. It's amazing how little you need sometimes to move something in the right direction for this, such as using an arrival at the beginning and a departure at the end, to make the video feel complete.

For recurring videos, watching structured lifestyle television can be a huge education in making successful, watchable online videos. We've been conditioned to internalise this type of formatting and it pays off when you employ it, making the video feel clear, to the point, and well produced. Don't be shy to be quite clear at the beginning about what to expect in this series and episode, such as the host saying, "Hi guys, thanks for joining me today. I've always wondered what it's like to eat in this amazing hotel. Let's find out!" As obvious and painfully clear as this is, the audience will know what's in store and won't be wondering what is the point of the video or where it is going.

Field Notes

An Executive Producer once tasked me with creating a series of short films with an eccentric talent who had submitted an amazing video of himself doing a spoken word poem. The poem was crazy, the timing was awkward and the production choices made no sense. And it was amazing. We absolutely loved it. I tried to work with him and tidy up the bits that didn't make sense so that they didn't "get in the way" and to my surprise it fell flat. The original had worked precisely because of his voice, the sheer force of his personality, that came through like one overwhelming wallop to the senses. We shot it again, this time slavishly deconstructing his style to recreate and version every little detail, and it worked perfectly. Knowing what you bring to the project is critical — are you adjusting the voice or facilitating it? Introducing a new audience or serving the existing one? Getting this point wrong can leave the audience cold.

Break down the bigger story into smaller sections and make sure that you understand how each one is supposed to work in terms of beginning, middle and end, all the while emphasising clarity of story and setting up questions wherever possible — will he succeed at this activity? Is this indeed the fastest phone? In the example above, the beginning, middle and end can be parsed as follows:

Beginning— "Hi guys, thanks for joining me today."

Middle— "I've always wondered what it's like to eat in this amazing hotel."

End— "Let's find out!"

Nothing epic here, and these elements don't have to be

literally spoken to camera but they should be present. You could replace the first line with a visual sequence of the host appearing at a location, which establishes the beginning thought that "the host has arrived somewhere". This quickly becomes more complicated when you've got a real scenario on your hands, but the basic questions should always be answered in one form or another, or delayed for a great reason like building viewer interest. Just make sure that this is authentically building interest and not an easy out to avoid answering the question.

I attempted this with a TV documentary that I was editing, hoping that viewers would be intrigued by the slow pace and mystery of the edit, and the producer's honest and brutal reaction was effective and clear. "Who cares? Why would I watch this?!" Answering that he was the producer and should know perfectly well was not the right answer. The right answer was to build a section at the beginning of the film that answered those questions in a way that built interest and eagerness to find the answers to the questions posed at the beginning, like "what is it like to eat in that hotel?". This provides an important guiding structure to the work, as the viewer will have an instinct to the pacing of the video. Once the food arrives, we know that we should be well into the video, and once it's gone, we know that we should be near the end. This process of setup and satisfaction is critical to storytelling, and it's best not to try and subvert it unless you are very aware of what you are doing and why, in which case you can reap the glorious benefits of breaking the mould.

When you finally put the script together, you likely won't need chapters or section markers, but the fact that it was planned out will undoubtedly be palpable and provide a momentum that keeps your piece feeling structured.

Factual

Documentary, editorial and journalism videos use the real world as subject with varying degrees of objectivity. I would shy away from journalism proper, as this is a very specific tradition with a burden of balanced perspective that is probably best left to someone trained in that area. Documentaries wear a veneer of objectivity but make no claims of a fair and balanced perspective, opting for "a truth" rather than "the truth", and we accept that the filmmaker is telling a story from a certain perspective with an objective to fulfil. This is arguably the same scenario as journalism, as shaking oneself of one's own bias is an extremely difficult task, but that's a discussion for another place. Editorial work is wholeheartedly subjective and offers a lot of creative freedom, as it is unabashedly a particular person's perspective on a subject.

These factual variants do share an approach to material, however, that has a complex relationship with the script. As with event films, you are likely in a position of limited understanding of what is going to occur, what the scene will look like, or what someone is going to say. You can still prepare a solid treatment that offers a clarity of objective, style and tone that can provide the production with a solid spine.

Research on prospective subjects and scenarios will yield some characteristics that, when tested against your treatment, should reveal where they may be useful in telling the story that you're trying to tell. You can then develop a series of questions for your interviewee that will help them to express what you're after or a possible sequence of shots that will portray the scene in a constructive way. Unpredictable situations can often leave a production team realising that they are shooting the

middle of a story, while the beginning has eluded them and they are desperately looking for an ending.

This is where a clear treatment and research will help guide what the section could (or should) be about, offering clarity to what kind of introduction to the scenario could be shot to set up the current sequence and a conclusion that would adequately sum it up and hopefully set up the next one. This involves an element of writing on the fly that is perhaps inescapable with real, live situations, but it is achievable if you have prepared the course of your story as much as the particular project allows. (A more detailed discussion of working with interviews to write a script is in the *Interview–Based* section in the Form chapter.)

Another subset of the Factual genre is the *host driven interview*, which could be a long form conversation or press junkets. These can either be researched and prepared, like traditional documentary interviews, or left to the curious mind of the host.

Music Videos

Good music videos are deceptively complex, and the styles run a huge gamut. There are general observations we can make about structure, however, to offer a bit of guidance to putting together a stronger treatment. First, let us loosely divide them into story–based and abstract videos. Story–based videos clearly offer a more straight-forward approach where you can write out the scenario and develop a script without dialogue. Supported with visual references that clarify the style and aesthetics of the video, you are in a good place to convey what you have in mind.

Abstract videos likely depend more on visual references, reputation and pitching ability, but we can still provide

some insight into the progression of the video over time. This variety walks a line between visual innovation and banality. As you introduce the visual style of the video in the opening moments, the viewer will become accustomed to the rhythm and shots that you've prepared and grow bored. Interest will be extended briefly when the lead singer makes their appearance (if they haven't already) but then you will again run out of momentum.

One technique of rejuvenating interest is by incorporating new perspectives or editing devices, but again you will run out of territory. A great many videos depend on costume, lighting or location changes every minute, each one more elaborate than the previous. An example would be that a rapper is alone in studio, just him and the microphone. Then his dancers appear 30 seconds in. Then they all have new wardrobe on a different set for minute 2. At 2:45, there is another change to a more spectacular set with more dancers and new wardrobe for everyone. At 3:30, with the end in sight but no more budget left in the till, the video will cut between all 3 setups to push us through the remaining moments.

A huge amount of videos follow this pattern, and while done poorly it is an obvious cliché, when done well it is a clever application of renewing interest and upping the stakes at regular intervals to keep your audience interested. The important thing is to plan change, which is really an essential element of any compelling story in any genre.

5 What's The Package?
Exploring the implications for each of the most common media.

While video is the predominant form of medium we deal with, there are a few others to consider, as there can be constraints to each. For videos, restrictions usually come about due to the method of distribution, as YouTube, Instagram, Vimeo, &c, all treat video slightly differently, which can have an impact on your writing.

I would definitely check the latest technical specifications as they are modified every few months, but there are things to consider in terms of writing creative for these platforms. Facebook videos appear to have different behaviour, depending on whether you are viewing from a computer or mobile device, so they may or may not autoplay. If they do, the video will be silent until the viewer interacts with it. Instagram has a 60–second limit and also plays without sound until the viewer interacts with the video, which means they may entirely miss the opening audio and have to wait until it loops around to hear it.

YouTube is the only one to offer chapter markers, which can be exceptionally useful for longer event or training videos. Vimeo allows you to replace the original video without breaking the link or losing your view data, like the number of views, likes or comments. These factors may not affect most of your projects, but it important to be aware of sound usage and time limits, as these could be a huge problem later on.

Loops
Loops, while not a medium, are a characteristic of how your video may be packaged and there are ramifications to consider when making them. They are popular social media content because they are eye–catching and, due to their brevity, people often assume that they are cheap and easy to accomplish. I've often had clients use *cinemagraphs* as a

catchall term meaning that they want looping videos, with little understanding of the term and distinctions between kinds of loops. It's important to make sure everyone understands what is being created, as *cinemagraphs* are quite challenging and definitely not what the client wants if the loop ends with a full screen graphic. Some distribution platforms don't allow GIFs and you'll end up using a movie file anyway.

Loops have different implications, but are generally video that is made to play in perpetual repeat. On the one hand, some distribution platforms allow videos to loop, so you can take any video and make it repeat. If the platform doesn't allow it, then within the single video file you could repeat the contents of the loop a few times, which fakes the experience for the viewer. They will see the image repeat for a while and then it will stop.

Once you make the video repeat, you may notice elements that exist at the beginning and ending of the video and are now suddenly adjacent, causing an unpleasant repetition. If you were beginning the video, for example, with a loaf of bread entering from the right side of the frame, and then at the end the same loaf of bread goes off to the right, then the loop effect would have this awkward moment where it goes off just to come right back on again. This would be better written if it came on and went off of opposite sides, or just remained in the same spot.

Seamless loops are ones where the repeat point of the video is not obvious. We've all seen excerpts from movies or loops made with a phone app where the ending feels very abrupt and the camera seems to jump as the sequence restarts. Seamless loops try to improve on this experience by making the transition flawless, tricking us into watching

the video multiple times because we're either not sure where the cut is or are wondering how the magic was done. There are two degrees of this kind of loop, and it's important to clarify with your client what is required. The example with the bread above would create a seamless loop if the bread goes off and then comes on from the opposite side. It would be a similar effect if we cut to a full screen branded graphic with a 'call to action' message and back to the bread at the start of the next go around.

The more ambitious degree of seamless loops is where the action is designed to make it extremely difficult to tell where the action begins and ends, and hopefully you've watched it multiple times before even realising it. This means the video is free from full-screen branded messages, as these would break the illusion of the loop, but could have an on-screen logo or message in the corner or in one section. This may need to be spelled out to your client, however, as it is important to be crystal clear on branding implications — if they don't understand they may just make you do it anyway, contradicting the qualities of the format. Similarly, you can't generally write seamless loops to an exact length, such as 15 seconds, as it depends on how the motion falls. Your options are to find a moment to extend or pause the action, retime the whole piece, or accept a duration that is close enough to the time requested.

The trick with seamless action in loops is trying to make a change during a repetitive action rather than during still motion. Imagine someone throwing a ball up in the air and catching it. If you tried to make that loop by starting with (1) somebody holding a ball, then they (2) throw it and (3) catch it, then stop the video and repeat, you would be doing something that sounds like a very logical thing to do and describing how you perceive the action to occur.

Unfortunately, in reality I can almost guarantee you that the person will have shifted their body weight to the other foot, tilted their head, changed where they were looking or that the ball would be in a different orientation so that the design on it is in a different place. Once you cut back to the beginning, all of these elements will move and vie for the eye's attention, revealing the cut in the loop and creating the opposite effect of what you are after.

If you try to cut during the moment of greatest action, however, you will look for the opportunity in the motion and recognise a great moment when the hands release the ball, beginning its blurry upward motion through the frame. Cut here and the eye will forgive a lot of these shifting elements that we described above, as they are all in blurry motion and difficult to keep track of. The sequence will then be midway through (1) throwing the ball, (2) they catch it, (3) they throw it again but we cut midway through. The overall action is the same but the effect will be far smoother, so when writing for loops try to find moments where as many elements as possible are in motion to begin and end it and avoid ones that require someone (or something) to be in the exact same position after moving.

Loop Perception vs. Selection				
Perceived Loop				
Loop 2			Loop 3	
He holds ball	He throws ball up	He catches ball	He holds ball	He throws ball up
Actual Loop Structure				
Loop 1 (in progress)		Loop 2		
He holds ball	He throws ball up	He catches ball	He holds ball	He throws ball up

Also consider that many distribution methods that support loops often play them without the sound until the viewer interacts with it, and GIFs don't have sound at all. Does yours work without turning the sound on?

Animated GIFs

On the face of it, an *Animated GIF* is just an image file format that has been adapted to hold multiple pictures, can play them back at a regular speed and can loop. There is no sound, and no implication that the loop will be seamless. People often make GIFs from movies or TV shows, and they generally are of a fairly low quality but this is not inherent to the format. They can look great, but writing them to be short is critical to this happening, as is working with someone who is good at encoding them, as it's a fine art of balancing various encoding properties while maintaining a good quality image. Most places that accept posting GIFs have file size limitations, like the 5 MB limit on Twitter that has expanded to 15 MB. The longer the loop, either the worse it will look and/or the smaller the image will be, so keep it as short as possible (2-5 seconds) to play it safe.

These work great for perpetually looping motion, like somebody doing a hula hoop. It is tricky to shoot these perfectly, but an experienced team can get it done, primarily by planning the moment that the cut should be made and then getting a lot of footage to work with to ensure a strong likelihood of getting a decent loop. As with other seamless loops, the important trick is to find a moment of quick action, which is the best place to hide a cut.

> **Comparison of quality vs file size for a 1 second cinemagraph**
>
> 971KB at 600x338 pixels
>
> 537KB at 600x338 pixels
>
> The grain becomes very pronounced in the compressed version, with a general buzzing when the GIF plays.

Cinemagraphs are an arty form of GIF, which is technically a plain old GIF but loaded with philosophical and aesthetic baggage. People expect these to be quite beautiful, perfect loops, so it is likely you will need to have an experienced compositor work on these to isolate the desired motion and freeze the rest of the frame. An outstanding example is *Infinite Coke* by superwhite, the forever-pouring can of coke. As with any GIF, these struggle against file size, so the shorter it is, the better it will look. Generally, you want the camera not to move and only a very small portion of the image to change, as when the file is made most of the frame will be designated as still. This trick of only a small portion moving is what allows the general quality of the image to be higher than the usual GIF. At the end of the day, cinemagraphs are just GIFs used to artistic effect.

> **Comparison of still image to holdout area for a cinemagraph**
>
> The full image.
>
> The white area is where motion will occur, and the black area is where the image will remain still.
>
> The smaller the white area, the smaller the file size will be.

360° Video

There is a lot of interest in virtual reality and *360° videos,* building on the excitement for the VR headsets that you hear "are coming" but haven't quite hit the market yet. As with loops, this is an extremely limited format that should engender careful consideration to the concept and I have yet to see an exemplary execution. Any "must see" lists of the best videos are less engaging than a well placed GoPro, as the salient feature of controlling your perspective isn't revealing anything better than the original point of view offered. Unlike true virtual reality which provides the ability of movement within a space, 360° videos have you locked in the position where the camera was placed.

The immersive experience sings when you place the viewer somewhere where all of the action is close by and there is no reason to move anywhere. Imagine being in the middle of a Radiohead recording session or a bull fight. These could be quite interesting scenes, but if the action

moves away then it's immediately frustrating that the camera can't go anywhere. Or if someone is speaking, there should be legitimately interesting things to look at, like say David Attenborough describing an ancient Egyptian chamber that you can examine in 360°. If the speaker is looking at the camera and talking about something fairly intimate, it feels incredibly rude to turn away and look around, and ultimately a boring thing to do if their environment isn't extremely engaging.

Further, this format doesn't accommodate edits very well. Each one results in removing control from the viewer and then returning it again, which is an unpleasant and jarring experience, as it takes a moment to orient yourself again. As for narrative work, since you'd quickly lose the plot if you were looking the wrong way during an important visual sequence, the important things must occur in the audio track — bringing us to the realm of a radio play. It's ultimately a device with very limited use, fantastic at immersive, environment or celebrity–driven situations but poor at what film and video do well, which is attempting to curate an emotive experience based on a series of things that took place in front of the camera. I remain hopeful that someone will pioneer an exceptional use of this medium, but I suspect it will remain in the company of 3D, which is occasionally immersive but, 60 years in, has yet to yield a standing contribution to cinematic language.

Short Ideas.

6 What Am I Actually Looking At?
Considering the various forms
of storytelling style.

Apart from the constraints of its particular genre, short videos can follow several different methods of conveying the story. These are:

1. Live–Action Narrative
2. Interview—Based
3. Direct Address
4. Observational
5. Animation
6. Abstraction

Live–Action Narrative

Live–action narrative is what we usually think of as a fictional, scripted video. We see someone doing something and engage with this world for a moment, like a family having a scenic drive to the beach in a car commercial or a parent preparing a surprisingly delicious frozen pizza for dinner. The lessons of storytelling that we can learn from traditional books on scriptwriting are best applied here.

Interview–Based

An *interview–based* style presents the upfront challenge of not knowing exactly what someone will say or how they will phrase it. Writing it out is still essential, though, as it gives focus and clarity to what each person might say and how each of these comments may relate to one another. This lets you determine who is the best person to say each thing and the necessary depth and breadth of each comment. Without this guide, it can be extremely difficult to judge if an answer is a good fit for the video, and you'll either capture an ill-fitting response or unnecessarily exhaust your interviewee with multiple takes to accommodate different variations of the answer. Ideally, each statement should build upon the previous to move your overall idea towards a compelling argument, much in

the way we were taught in school. Make an opening statement, prove it with a few examples, and provide a conclusion that highlights how your examples prove your statement. A video for 'Massive Bank' that wants to show how personable their staff are may have the following flow:

> VOICE OVER
> At Massive Bank, we pride ourselves on taking care of the customer first.

> EMPLOYEE
> I try to find a moment in every day where I'm able to make someone's life better, whether it's helping them get that loan or just letting them know that we're here to help. That's how my boss treats me, and our team stands by it.

> CUSTOMER 1
> I never thought it could be like this... I'd nearly given up hope after being turned away without even an appointment at 5 or 6 other banks, but at Massive Bank, they welcomed me with open arms. They listened to what I wanted and found a way to make it happen.

> CUSTOMER 2
> Everybody here seems to know my name! It's really a refreshing and friendly place. Every time I come in, Cathy, my usual teller, asks about my grand kids by name. It's sweet.

> VOICE OVER
> Whether it's our employees or our customers, we're committed to being a place where people come first, always. Massive Bank.

This script also provides a first opportunity to consider what b–roll sequences are required and what their sub–text should be. Consider how much less interesting it is to use generic office imagery that could be applied anywhere in the video than a sequence that communicates how busy, cooperative or diverse the employees are, thereby appropriately supporting the interviewee's statement. During the EMPLOYEE's line, for example, a busy office shot would be much less supportive of the statement than one employee rushing to hand another one a file as elevator doors close, visually suggesting that they help and look out for each other.

Once this script is approved, you are then in an excellent place to deconstruct each statement into unique building–block questions that lead to this sort of answer, and are fit to purpose for the specific interviewee. This deconstructive philosophy is much more successful than a 'standard questions' approach. If you just write out "good" questions, they are likely to be generic and not specific to the individual. Many times, I've been given questions that my client wants me to ask a subject and they are painfully general, vague, or invite one word answers. Well constructed questions take into consideration why the individual has been chosen and imagines what would elicit the answer you're after. Avoiding short yes/no answers, they should follow each other from one topic to another so that you are creating a conversational flow. Few things are more alienating to an interviewee than randomly jumping from subject to subject with the feeling that their answers have no impact on the questions asked.

Eliciting the answers from CUSTOMER 1 would require a little research to make sure that you've got someone who can speak to that sort of experience, and then

you could develop a few questions to help that answer come out, such as:

—Is your experience at Massive Bank typical of dealing with banks?

—Did you try any other banks before Massive Bank?

—Did you expect the treatment you received at Massive Bank?

Consider how much more likely you would be to get a decent answer using tailored questions like this with CUSTOMER 1 than the common approach of using the same questions for both, as in:

—Please describe what makes Massive Bank unique.

—What do you like about Massive Bank?

—Is there anything that sets Massive Bank apart?

If you are writing the script after the interviews have already been shot, then an effective starting point is re-organising the material by the most relevant criteria, say first by subject then by speaker. This will let you get a strong sense of the material that you are working with, and can either be done in an edit program or by transcribing the interviews. Then you can print, cut and collate the material in a tactile way or keep it in a document for quick and easy re-arrangement. I would caution against truncating sound bites shorter than full statements that end with the completion of the thought unless you have developed an ear for audio editing and can identify when you can get away with omitting or replacing a word. Editing (and

production) experience is incredibly valuable in this situation, as you can then re-order complete sentences or, if recording additional audio is an option, you can identify when is a good point to cut into the existing quote and record new audio to begin or complete the statement.

Field Notes

This technique is one of the movie–magic moments where just the tiniest clip of on–screen footage legitimises additional audio recording and the viewer is convinced of the authenticity of the moment. I edited a feature–length poker special for the World Poker Tour and had the privilege of visiting the set to see how the multi–camera event was recorded. The producer wanted me to get my head around how the 20+ cameras were related in real time, and the reality of the production was quite enlightening.

As an authentic gaming event, the pocket camera feed that revealed the players' cards was fed into a locked room where two licensed gaming officials would warn the director if the view was obstructed. They would not reveal any other information, so the integrity of the game as a legal gambling event was maintained. This meant that the commentators had no insight into the game and could only observe tense moments and outcomes.

Their comments that offered insight into strategy and played up what players actually had in their hands was sent to me separately a few weeks later as a new voice recording session, made after they had been provided knowledge of the cards in each players' hand. Provided that I occasionally showed the announcers sitting at their desk, it was beautiful movie–magic when I cut into the audio. You'd never suspect the trickery at play, and happily bet that they were making their comments off the cuff.

An important distinction for *interview-based* videos is whether the interview needs to take place on camera or not. Like *V/O-driven* videos, *non-synchronous* — or audio only — interviews offer an incredible freedom in sculpting the answers to maximum eloquence and effect, and provide the most relaxed environment for the inexperienced interviewee, but provide the extra burden of determining more extensive on-screen elements.

Another point worth considering is if your speaker is the best person to speak on a subject. I wrote and edited a documentary about an arts figure with the obligatory title, "The Legend Behind The Legend". Unfortunately, the long-gone director had only shot an interview with the subject, which created the awkward situation where the subject came off as a presumptuous and boastful braggart rather than an important innovator and well respected member of the community. Fortunately, we were able to organise some additional interviews with appropriate figures who established the respect and influence of our subject up front, letting his clips serve as interesting storytelling sequences.

If your interview turns into a teleprompter session, be extra careful to consider the readability and pacing of the script. The low-end, portable machines are notoriously clumsy to control and present a reading challenge to the performer — unless the speaker is very experienced, it may be difficult for them to keep a good pace for an extended amount of time.

Finally, I recommend keeping a tight cap on the number of characters involved. Clients can run away with the excitement (or political necessity) of a cattle-call of interviews, but consider the length of the piece and how

many people you can get away with introducing. How would you feel about meeting that many people in that span of time in real life? How many are required to make the point? An excess of characters with no consideration of what this multiplicity brings to the project dilutes the strength of the message and can just confuse the viewer. Introductory lower–third messages are helpful, but can quickly become overwhelming, and aren't a satisfying solution to the problem. It's best to be focused on who is being interviewed for which reason, as you'll understand their piece in the puzzle and have a starting framework to devise their questions in the deconstructive fashion we explored above.

Direct Address

Direct address is where someone is speaking directly to camera, which fits very naturally in the *review* genre. Neither narrative nor interview, these take place in the moment as it is presented and feel like an authentic moment with the speaker. This could be a fictional character talking about a product, as in the amazing *The Man Your Man Could Smell Like* campaign for Old Spice, or a celebrity cooking segment that highlights just how great brand X crackers go with dip. For the former variant, you can enjoy the freedom that narrative creativity provides, while with the latter you should research the work of your contributor. Will you adapt their style or try to present them in a new light? I would consider the channels of distribution and to what degree you are trying to seamlessly fit into their existing online presence. Maybe writing a bit of simplicity or awkwardness into the script would effectively emulate their self–recorded vlogger style, or you could go against the grain to attract positive attention. (We discuss this balance in detail in the *Review* section of the Genre chapter.)

Trying to exactly recreate someone else's idiosyncratic style can ring false with loyal viewers, so if this is called for I would try a loose script that anticipates their participation to rewrite to style. As always, this script often serves as the start of a conversation that can lead you to the right answers, as clients are sometimes reactionary in nature and incapable of providing the information that you need up front. I was once asked to write a video based on the following "brief" for a pharmaceutical client — "A woman rubs deodorant on her face." That's it. My usual investigative questions were shut down and I was left to just write something and accept how it was all wrong, but at least it gave a position to react against and the answers that I needed were soon made clear. A couple of quick drafts later we had a viable shooting script.

Observational
In contrast to *direct address* is *observational,* where the subject does not acknowledge the camera. These two personality–driven styles equally depend on adapting or reacting to an existing talent, with *observational* usually depending on witnessing the talent's interaction with someone else, like on an interview show or hidden camera. An interview show depends a great deal on your interviewer's preparation and natural ability, varying in style from Larry King's off–the–cuff, preparation–free interviews to meticulously researched and constructed questions that lead the conversation down a particular path.

Writing for hidden camera is very challenging, as there are many factors that affect the production, from physical logistics of where to place the camera operators to legal concerns of obtaining permission from subjects without unduly revealing your presence. Effective writing for this style demands that the scenario works for as many different

reactions as possible. It is hard enough to get an entertaining and usable reaction, so if you are depending on people specifically reacting in a particular way, like being scared, confused or laughing, then you have made it infinitely more difficult to produce. It is far better to develop a scenario that accommodates a good variety of reactions and depends as much as possible on your performer, one of the few elements that are in your control and favour.

Animation
Animation is a vast and wonderful domain, but I would be cautious about recommending it to a client without there being specific visual references in play. Everything from *Steamboat Willy*'s 2D character animation to Stan Brakhage's hand–painted camera–less abstractions count as animation, so it is very easy to have a huge misunderstanding with your client. I've heard people dismiss animation as "childish", and can only assume that they are fixated on a *Dora The Explorer* treatment for some reason, which is an appropriate treatment for its audience but hardly defines the category. So I will always present references at the treatment stage before the script is even written to make sure that this is in fact a viable scenario.

If the budget is a concern, you should definitely get some advice from an animator to determine which specific looks and techniques are viable. A bit of stop–frame animation using objects rather than puppets could be very easy to execute, but sophisticated character animation where an anthropomorphic figure is walking, gesturing, blinking and talking all at the same moment may require an experienced cell animator to draw and the various production positions to support its completion. Or, if you are manipulating drawings or photographs, an experienced

compositor may be able to use photo-manipulation techniques to achieve a comparable effect in a much quicker way. But the looks are extremely different, so tread carefully.

A major subset of animation is *motion graphics*, typified by primetime news graphics packages and eloquently executed in infographics. These are commonly misperceived as quick and easy to execute, when in fact they require a keen design eye and the requisite aesthetic planning and organisation of objects in space. This is a set of skills that falls under animation but is not endemic to all animators, so it is a good idea to have the correct team lined up before getting too far into your concept, and to know the difference between the main specialists:

Cell Animators are animation–focused artists who can draw characters frame by frame, and the people we traditionally think of as animators.

Stop Motion Animators are also trained animation artists but focus on the movement of real objects as opposed to drawings. A stop motion animator would control a rigged puppet or move people or objects in space over time.

3D Animators are adept at creating things that can be viewed from any perspective, usually for photo–realistic effect. Most animators will have a piece of software in which they specialise, so some will have more capability to do effects like water easier than others, so it's best to discuss in detail what the job entails.

Compositors are digital visual effects artists who specialise in manipulating imagery over time, like a video equivalent of a photo retoucher. This is the person who can

stabilise a shaky shot, remove a green screen background or have a gun flare appear when a fake movie gun is supposed to fire.

Motion Graphics Artists are the people who can create show graphics, like sports or news opens, extrude a logo and make it spin, make a graph adjust itself, or other completely computer–generated abstract magic.

There are extensive specialties within these categories, such as 3D texture artists or people who focus on tracking, and someone who does one of these jobs may not have skill in the other, so it's best to have the discussion.

Motion graphics can be a life-saver to act as explanatory b-roll that both clarifies what an interviewee is saying and removes the synchronous picture so that you can cut the audio as required. These elements can also be easily written into a script, and like everything else work out best when not an afterthought.

Abstraction
Abstraction is another important form of short form video, though perhaps most commonly seen on in–store monitors and behind graphic text or logos. This is often the domain of motion graphics artists, but a huge variety of techniques can be employed to create abstract material. Take a look at the re:voir or Anthology Film Archives websites to get a taste of the vast territory explored by experimental and abstract filmmaking.

I would argue that abstraction isn't a free–for–all of randomness but rather an interpretation of story that rejects traditional narration as its driving force in favour of something else, like the evolution of a formal quality. An

engaging abstract film could explore the evolution of line, colour, texture, shape, form, value, light, intensity or space over time, or in a particular place. Or it could examine the occurrence of one quality in a defined area, such as the letter A on signage in New York City. That film would definitely be free of a traditional narrative story and be categorised as abstract or experimental, but would still have a sense of purpose and structure that can leave the viewer satisfied that they are engaging with the artist. Similarly, I believe that any good abstraction will have a definition of the territory it is trying to explore, and a sense of purpose that is employing to drive the film through change, subject to the usual aesthetic and instinctive choices of the filmmaker. From this perspective, you can still write about a concept that explores abstraction in a way that is intelligible to someone else, which is an essential part of writing and pitching.

7 Take It To The People!
Looking at how the various methods of distribution can affect creative.

The method of distribution can ultimately have an impact on the writing for your video, as different platforms — YouTube, Facebook, Vine, &c — can have different technical implications that help or restrict the project. All platforms have their unique features and these technical details are frequently revised, so it is wise to review them when you plan a new video. Also, there are occasionally third-party workarounds if your video is viewed through another method, such as a YouTube video hosted on a WordPress site, but these sorts of technical concerns should be discussed with the marketing and IT specialists involved. The three main methods of distribution that we deal with are:

1. Online Hosted
2. Online Live-Streaming
3. Location-Based Offline

Online Hosted

YouTube is clearly one of the giants of online distribution, and it has a few implications worth consideration. It allows chapter marks, which are a great organisational device for educational and longer videos but may not come up very often. On the restriction side, you can't replace a video once it is uploaded, so any later changes or revisions will mean sacrificing your existing link (which may already be out in the social sphere) and view count.

If revising the video with newly written material after the initial release is required and you want to maintain those links, then Vimeo is your host. But there are no chapter markers.

Facebook has grown in significance as a method of

video distribution, but it presents a serious concern with autoplay and sound playback. These features appear to change from time to time and across viewing platforms, so you may need to write your video in a way that accepts people may not hear the first moments of your video and highlights that they should interact with the video to enable the audio track. This may mean writing a very attention-seeking opening sequence that aggressively captures the viewer's attention or explicitly featuring an on-screen element that is calling for action, such as lower-third text that says, "Turn on your audio!"

Instagram has a 60-second limit and audio only plays if the viewer interacts with it. Square versus rectangular aspect ratio isn't usually a concern for writing, and isn't a technical requirement, but clients may expect it. *Vine* videos can be up to 6.8 seconds in length and require some technical know-how to accomplish the upload.

Comparison of regular 16:9 aspect ratio to square 1:1

16:9 frame

1:1 frame

Online Live-Streaming

Various *live-streaming* services exist as well, such as Periscope and Facebook Live. The main concern here is that you can't live-switch to another camera source without a complicated third-party setup, so writing should consider real-time executions and doing without graphics overlays,

selective audio mixing or cinematic music if you want to maintain the simplicity of production of someone authentically shooting on their phone.

Location–Based Offline
Finally, we have *location–based offline* videos. These play in a specific place in the real world and aren't accessible from the online world. This could be a projection at a stop of a transit system, like in the metro of Barcelona, or on jumbo digital billboards like in Times Square, or in a motion–activated screen above a urinal (ah, the glory of show biz).

This method covers anywhere that you could connect a way of seeing video that is an offline system, and will have audio or duration limitations specific to that particular system. A common subset of this category is *in–store visuals,* the content that plays on screens inside a shop or display. These can either be looping or part of a playlist of items that will take turns playing for the clientele. It's often visual–only material, so it could be some colourful ephemera or literal models on a catwalk, but it could also be illustrative sequences of how products function.

In–store visuals have no inherent direction that the content should go — anywhere from behind the scenes manufacturing footage to colourful abstraction — which catapults it into a full–fledged method of distribution, albeit closed–circuit and offline. They can inform, entertain, educate, demonstrate, or anything else you can think of, so this method has an incredible versatility of function — but it often has a quite restrictive technical criteria that can be a major complication (or opportunity).

In–store displays can be mounted vertically or in multi–

monitor configurations that increase complexity immensely. These can mean extremely large resolutions, unique aspect ratios or bizarre shapes that aren't rectangular at all, and require dedicated hardware to map the image across the different displays.

While this may not appear to concern you at a creative stage, it can be incredibly important as you'll benefit by considering how the material you are creating will be framed. In the simplest scenario of using a sideways monitor, you may need to shoot with a camera mounted sideways, otherwise you could be in a situation of having to stretch up the video's resolution to fit the monitor, which will look soft and likely be difficult to find a new composition that works. On the up side, a portrait—oriented monitor allows you to frame the human body MUCH easier, and is perfect for things like catwalk footage, allowing clothing retailers to show their wares in motion.

Comparison of regular 16:9 aspect ratio to square 1:1

The original 16:9 frame

Camera framed sideways for 9:16

Original frame scaled and cropped to 9:16

The same image mapped to a set of irregularly arranged monitors

The same image mapped to a set of six 16:9 monitors in regular arrangement

Field Notes

Bizarre frame shapes can be difficult to work with, but a little low-fi ingenuity can go a long way. I was once tasked with making stills of a group of people for a Facebook page so that the larger banner area had most of the group and one person appeared in the little profile picture. I needed this to line up perfectly, and then do enough different versions to feature each person. I screen-captured a Facebook page and printed it out to a size that matched our monitor, then cut out the spaces where each face should be. I overlaid this on the monitor and used it as a guide to make sure that everyone lined up perfectly. The planning was time-consuming, but then the execution went smoothly.

Another complexity can be that there is rarely sound used with in-store displays, as the store will have its regular audio experience on the sound system. This leaves you three main options, (1) subtitling any necessary audio, (2) designing the video so that no audio component is required, or (3) building any text in as a graphic element that is nicely integrated into the video.

As always, clarity of purpose of the video is critical, as there are additional options not usually employed with other methods of distribution, such as tonal or atmospheric applications. In-Store Visuals are a fantastic outlet for abstract or playful imagery that suggests seasonal interests but emphasises colour and form rather than a logical message, such as images of colourful parasols rotating or ice-cream melting in time-lapse. For creatives, this is a great outlet for creating visually driven soft-touch videos. Being on-brand is always extremely important, but the need for branding per se is often reduced because the physical location where the video is viewed (ie. in the store) is abundantly branded.

8 Squeezing Your Brains.
A process for creative ideation.

Coming up with creative ideas is the second step in writing your script. The answers to your essential questions that are in your brief— what is the objective of the film? who is the audience? — are absolutely critical, and I can't stress strong enough that you shouldn't do go forward without a good brief. Don't do it.

Don't do it. Don't do it.

Please. Don't do it. Save yourself the pain. There is no way to tell if your idea is appropriate for the task at hand if you don't know what the video is supposed to accomplish. The objective is the other half of the velcro to your creative idea. If the two don't stick, it doesn't work. You don't want to be overly concerned with the suitability of your idea when you're generating ideas, but you need to know the ballpark you're playing in so that you aren't completely wasting time and lost in the despair of the Unending Cosmic Gulf Of All Possible Creative Ideas.

Knowing what the video is supposed to accomplish (like announcing that a new toaster is coming to market) and to whom (say, to young dads that are F1 fans) gives you a great starting point to embark on your creative journey. You can brainstorm whatever comes to mind, and when you get stuck you have some questions that you can ask yourself to stimulate new areas of thinking. "What do F1 cars look like? What's the appeal of them? What kind of guy likes Formula 1?"

If there are any of those Important People's ideas floating around, then you are better off acknowledging them. If I don't love an idea put to me in this way, then I usually try to adapt it to something that I think is workable, subverting or altering the troublesome bits so that I can get

on board. Fighting or dismissing it straight on is quite confrontational, but I find that if you return with a freshly developed version of that idea in the mix then the person will feel validated and respected. They'll recognise that you took their inspirational kernel and put some work into it, proving the value that they had spotted in its infancy. If you have to move it quite a huge distance, explain how the new version grew out of the idea that they put forward.

When generating ideas, I recommend that you develop your process and respect it. Personally, I'm a firm believer in finding some tranquil space away from regular noise and distractions and letting my mind get lost. I put on some headphones and find some music that comforts or surprises me, get out my favourite fountain pen and some paper, and sketch, doodle or free–associate words on the page to get my brain going.

After a first barrage of single sentences or words that are meaningful to me, I'll run through image libraries of pictures I've taken or found online to jog me in a different direction, or image–search different phrases to see what comes up. (By the way, if you don't know it already, one of the most beautiful features of a Google image search is the '-' function which can remove keywords or website sources if your search is polluted with an unwanted factor. If you're looking up 'happy families' but have tons of stock imagery in there, change your search to 'happy families -stock' and suddenly all of the sites tagged with the word 'stock' will be filtered out. Bless 'em.)

Some sticky jobs may have you asking if you're the right candidate to write it and there's just no wriggling out of it. So how can you make yourself the right one? Are you overlooking some personal quality that is relatable to the

subject at hand? Can you figure out what is appealing to the audience about the subject and draw a personal parallel? Or can you hire in a partner to give it a blessing? For that *Black History Month* promo that I mentioned previously, I hired in a colleague to help guide me away from miss–stepping. I wasn't the right person for the job, but I was able to correct the situation.

If you're writing for a project that has an element that you are struggling with, I think it's best to be honest about how you feel and get the bugs out. Admit it to yourself. Find a safe place and express your irritation or displeasure until it's stopped being an elephant and become a reverberant echo of laughter. Now you can start to work. Figure out your angle. Is this the appropriate opportunity to undermine the project with your own subversive subtext? Probably not. Or can you think of a way that you can make this distasteful part work? It is, after all, an opportunity to do something that you wouldn't usually do, or present this element in a way that it wouldn't normally be portrayed. I find after the initial bad reaction my insides feel satisfied, I can move on with the business at hand, and feel excited and engaged with the thing that I was stubbornly resisting.

Once I've gone through a few pages of scribbles, I'll assemble all of my ideas onto a fresh page and jot them in the briefest form possible, just enough to sketch out the idea. Do they have enough meat on them? Are they engaging enough to hold the prospective viewer's attention? Is it an idea that can actually be written out or is it wonderfully high–minded and resistant to actually taking shape? I've been given great–sounding themes that don't really work, like applying the idea of "life hacking" or "Ikea hacking" to a soup manufacturer. How the heck do you hack a soup?! Testing the idea against a various

manifestations is critical to know that it is an idea that could develop into a concept, just as testing the concept against the original brief is critical to knowing if it is an appropriate response to the brief.

Sometimes you can picture something, but it's not clear where the idea should go. This could be the result of confusing subject with story, and is revealed by testing out how the creative idea would manifest. If you can't picture how the video would play out, or realise that it's got the depth of a single frame and you don't know where to take it, you've likely struck on an interesting subject without a story. Keep the note on the page for later, but it may be a dead end.

But please don't limit yourself to a literal, traditional story — abstraction and experimentalism has taught us that a great variety of things can work as a story. It just means change over time within certain parameters — a framework and rules of engagement. For example, you could show a series of blue objects and we're looking at them in order from lightest blue to darkest blue, which is a story of the colour blue and it's various tones. Or a series of window shapes, organised from square to circular. Story is a rich and engaging concept, and these subtle cues of structure and form not only help guide the creative hand in selecting what is a good fit for the project at hand, but tip off the viewer that order is afoot and that the video has a purpose.

Don't discount the importance of calculated procrastination when you are generating ideas, this process can take a while and you may need to take a break or shake things up. I usually engage the brain for a bit then back off, letting things churn in the background. I expose myself to different things as a bit of a distraction to engage my

curiosity, then engage again. Like doing weight training, work intensely and then take brief rest periods, then apply yourself again.

Vetting Ideas
With my ideas selected, I'll test them against the objective and target audience to see how well they fit. If they're not on the mark, can they be corrected or are they best dropped out of the running? I'll often come up with variant ideas at this point, too, realising that some ideas could go in different directions.

A good idea should have a clear focus on what is necessary for the integrity of the idea. Restrict it to its simplest, clearest elements that still hold together — this is the core idea. Anything else is a stylistic choice and it is important to know the difference. Sometimes, a colleague will throw out an idea for another layer to a concept because they're trying to make the idea better. You need to consider if this adds a layer of texture to the idea, or if it is just making it more complicated. Do these additions make the concept harder to follow? Are they a repetition of existing elements? Does it make the video extra difficult to produce?

A good idea should only have what is necessary, no more. Style can dictate some flourishes, but you need to know that these are sustained by the idea and do not distract from or burden it.

Remember that the motion image is better at eliciting emotion than intellectual or logical discussion — outright convincing or explaining something to someone is far less compelling than making them feel something, and it also takes a surprisingly long amount of time to accomplish.

Use this brief time you've got the viewer's attention to compel them towards some sort of action — buying the product, visiting a website, watching another video, changing their behaviour, or whatever is the objective of your film. This final appeal to participation is the "call to action" and will normally be explicitly written out on screen with the brand logo at the close of the video.

Campaigns

When writing a concept that requires multiple iterations, or a campaign, it's all the more important to know this core of the idea as you they will all need to feel like they belong together. Repetition of certain elements is necessary to innovate variations on a theme, but you want to be repeating just what is necessary to form a series and not what will make the videos feel repetitive — so things like tone, aesthetics, voice, pacing and duration become very important, with a very solid concept of each guiding you through the iterations. Many times I've heard people suggest that videos in a series could be completely unrelated, but that doesn't come off like a cohesive campaign — imagine how your audience will perceive these videos. Would they connect them? If that's not important, knock yourself out, but be in control of whether your making a campaign or simply a bunch of videos.

Reviewing The Ideas

Before you put these ideas forward to anybody, I think it's best to do a taste check. Does it reinforce negative stereotypes? I know it's not your job to be the morality police, but you are on the planet in a society and have a responsibility to not be a piece of human garbage. Is the mom preparing a meal after she's worked all day and dad is just chilling out with teenage kids? What's that about? Who lives in that world? Maybe you can flip it up so it promotes

less dated values. These kinds of adjustments push your idea to a better place because it's by necessity fresher. Remember, your audience has seen endless hours of this stuff. Respect that sophistication and stand up for it when you're putting forward your ideas. You're a guardian of what gets out there, so make an effort to keep it in step both aesthetically and ideologically.

If writing to budget is a concern, I would leave it to this point as well to consider if there is a way of developing a given concept so that it can fit in the budget range. Earlier than this, you'd be murdering ideas before they have a moment to breathe, and later than this could be dangerous as you're putting ideas out that can be difficult to deliver. I wouldn't go into budgetary details, but do gauge if this is a bigger shoot requiring a lot of people, specialties or locations. If so, check it with a producer before moving on.

Now don't just jump into writing scripts — this can be a huge time waster. Don't write the script until its time to write the script, and that comes after you've given a top-level pitch, a fleshed out one-page, and then got approval to continue development. So keep your ideas at this very brief, sentence-long stage. Ideally, you'll have a good relationship with your creative director or a colleague and you can pitch them these ideas. Just this verbal quick sketch should be enough to see if they perk up or their eyes glaze over. Their reaction should help you whittle down the list to a few winners, and you may elicit some good revisions.

This is a fantastic place to be — you've done the work, proven you've got the goods, and you're on the way to creating something interesting. You've also avoided the worst kind of creative — derivative copies of someone

else's idea or the one-size-fits-all approach, where every job gets pitched the exact same treatment. That happens sometimes, though, and we just have make the best of it.

Each idea should get presented in a longer version, either as a single page in a presentation deck or separated in a treatment document as various concepts. These should be concisely written, as a few sentences, with accompanying images that evoke the idea. It's important to develop your visual imagination so that you can see a video unfold and spot where it sags or sings so that you have the confidence to put the idea forward at this point — you don't want to be in a scenario where you've promised something that comes out flat when you're going to write it out. Make sure you're looking forward to fleshing each of them out.

9 Write It Up.
An examination of the essential elements of a strong treatment.

The treatment is your best friend. I would never do a job without one. It is your contract, it is your safety net, it lays out all of the important parameters so that there are as few misunderstandings as possible. A good treatment forces clarity between everyone involved and avoids the terrible scenario where a project is delivered to blank stares, anger, or objections that "this isn't what we talked about". Take it as a tool that helps keep you honest, accountable, protected, and helps develop your ideas with integrity.

Building on the client's brief, a treatment restates some of the critical information and presents your creative idea. In the first round, it should present your concepts. Once a concept is approved, a revision will strip out the other ones and then develop your winning concept into a synopsis (if required) and then a script. Depending on the style of your company, this treatment could be put forward to the client or pasted into a deck, which is a PowerPoint or Keynote presentation so named because when all of the pages are laid end to end it takes the length of an ocean liner. Well, no, but they are often well above 100 pages, encompassing all kinds of information and the key creative proposition would be only a small part. This format is usually reserved for clients that are outside of the industry and there is no agency intermediary.

First, identify the *client, writer* and *producer*. You never know who will be looking at this document, and it's important that they know who is responsible for it.

Clarify the *objective* of the film. It's extremely important that you narrow the focus of the film down to one purpose. Fight off any calls to have a laundry list because it just doesn't work, the movie will end up being scattered and the audience will not receive the multiple

messages. If you are pressed at having multiple messages, try reading out the blurb and time it. You can demonstrate that this litany takes nearly as long as the video itself is supposed to be... and if asked to repeat it all, you'll be hard pressed to find someone who can remember it. Hopefully you're not dismissed with, "that's the creative challenge!" because it's an unrealistic one. Stick to one objective. If having multiple messages is irreconcilable, try to suggest making a series of films and each one could have a singular focus on the given objective — but still, to maintain the coherence of a series, you would want one over-riding objective that is common to all of the films and then a series of secondary ones that modulate between iterations.

Identify the *audience*. Nothing is successfully written for all audiences of all ages because there is very little that all audiences of all ages have in common. There is a core audience that you should have in mind and various ancillary audiences that have an overlapping interest. You have to target for the core and avoid alienating the ancillary, but you can't write for all people all the time. These are the people that you will imagine vividly and try to sculpt a concept that you think speaks to them.

Clarify your *deliverables* before you get too far, as it's very important to know if you're making one fifteen second video or thirty-five sixty second videos. Is there a subtitled version to be done, or an alternate language that needs to be shot? People tend to mention these things very, very late in the game, which can be a massive headache. Give your later self a high-five and get it down now.

Indicate the *budget range* so that anyone who reads the treatment understands the scope of the production. It can serve as a good reminder of the context and flag any

concerns about the financial ability to execute the concept.

Sample Treatment

Company Name
Creative Treatment

Project: Brand X Widgets
Client: Brand X
Document Version: 1

Creative: Your Name
Date: xx/xx/xxxx

Objective:
To launch Brand X Widgets to market.

Target Audience:
Fathers aged 35–50.

Budget:
£10,000

Deliverables:
(1x) 60 second video
(2x) 15 second cut downs for social media

Distribution:
YouTube for the 60 second video, and Twitter, Facebook and Instagram for 15 second versions.

Timelines:
Delivery by August 15. Tentative shoot date August 9.

Background:
On the back of their overseas success with Widgets, Brand X is introducing them to a new market. They have had tremendous success with the target audience and the client would like to continue the tone established in their original marketing campaign.

Mandatories:
Include blogger as host TBD by July 25.

Tone:
Light-hearted, playful, colourful, inclusive. See original campaign for reference.

Concepts:
Concept 1
This is where concept 1 is written out in brief but exciting detail.

Concept 2
This concept is just as tantalising as the previous, it must be very hard to choose between them.

Synopsis:
Pending concept selection.

Script:
Pending concept selection.

Visual References:
Images are pasted here with a description to explain their value in the context of this treatment.

Indicate the *method of distribution*, as this can affect duration, framing aspect ratio and the audio. This can sometimes trigger multiple deliverables, as framing and graphics that fit a rectangular video may cause problems in a square one.

Give *timelines* so that there is clarity of how quickly this must be approved, executed and delivered.

Declare any *mandatories*. Are there any elements that must be included or excluded, such as talent, a location, an event, an interview or animation? This can be really critical to your creative, as a cooking video that is overtop the assembly of a recipe in the "tasty" style that doesn't feature your celebrity chef's face (because you didn't know the chef was involved) won't go over very well.

Detail the *tone* of the video, which is the overall sensibility. Is it funny, aspirational or serious? Are there brand characteristics you should stick to, like adventurousness or light-heartedness? It's a good idea to review brand guidelines if they're available, so check any brand documents for clues. If you're lucky, they'll have something to work with, and if you're not, they'll be bland, generic, predictable texts that don't give you much to go on, but may indicate a general middle-of-the-road style of consensus at the client.

The *look and feel* or visual style of the video is important to describe, as there are lots of ways to imagine the same thing and you're trying to bring everyone to the same place. Image an interview–based piece. Is it people sitting against a seamless backdrop looking into the lens? Or are they walking and talking to an off-camera director in the cinema verité style? Are they formal and respectful, or

casual and relaxed? Is it boldly colourful or black and white? If you have multiple concepts, then this information should be contained in each.

Present your *concepts*. Name each spot — this gives a focus to the idea, immediately setting the tone and perspective, and gives a great way to remember it. Be sure to outline each of them briefly and in a way that explains how and why it works, not a play by play of how the script will function. You're selling the idea here, not necessarily the execution.

I would caution you against presenting the one idea that you really want to do — expecting the world to recognise its genius and fast-track it through production — and offering a second, safer backup idea that you despise as an obviously-never-to-be-chosen alternative. Seems like a great way to guarantee your good idea gets made, no? It's not worth it. Every time I've heard of someone doing this, the client picks the terrible idea. Every time. And then you spend the rest of this job developing something you regret. How good a job do you think you'll do on it with this enthusiasm?

Field Notes
I once flipped this strategy the other way around and it worked great. I came up with a pretty crazy idea for a men's body shav— sorry, *groomer* — and thought, "they'll never let me do this, even though it will look really cool it suggests using their product is shameful and that body hair is disgusting". So instead of pitching a second safer idea, I pitched an even crazier second idea. This made the first one seem eminently safe and reasonable, and I got the green light on the spot.

Visual References

A really helpful and dangerous thing to do is provide a reference picture with your treatment. Helpful because it can clarify what you intend to do, but dangerous because if done wrong you've thrown the reader way off the path. A good reference explicitly states what is indicative about the picture and what is a bad steer, such as: "This shows the colour palette but is not a compositional reference." This kind of selectivity of thought is really helpful to break down this problem to a manageable and inspiring task — looking through pictures with a narrow criteria can really open your mind to unexpected observations and inspiration.

The flip side of references is that people want to see a picture of something that, if your idea is more than a derivation of existing work, doesn't exist. Unfortunately, there's just no winning this argument, but we do have a virtually endless supply of images to peruse online, and Photoshop to help concoct a mock–up if it's just not out there. I've often created low–resolution illustrative images that serve as a sketch to explain what I'm after or generate interest, and recommend doing the same.

They serve as a mood board to the client that express all manner of things that would either take too long to explain or would dilute much of the character that you're trying to convey. References are especially useful to convey key moments in the concept, casting ideas, the setting, the lighting, framing choices, styling, pacing, colour relationships, or pictures that convey a mood or serve as tonal inspirational.

Similarly, online links to existing videos can serve in the same function, though for the sake of the treatment it's a good idea to put in a reference frame to provide a reminder

of the video as well as a brief paragraph of justification to clarify the context as we've discussed. I've also made video reference mock-ups before to demonstrate something specific, which help me work through the process of how to accomplish it and demonstrate to the client that I'm the right person to accomplish the job.

Sample Visual References

The exterior of the shop should have an excess of signage, like these identically printed yellow and black signs.

The colour scheme of red/white and yellow/black, and the saturation, are perfect.

The tables out front are not a good reference.

The interior of the shop should contain extreme piles of filthy, old, hoarded materials. The general level of mess here is perfect, though materials will be appropriate to a DIY store rather than exclusively the paint supplies depicted.

The shop is next to a prison, so it should have barbed wire like this.

The exterior should be as close as possible to sharing one side with a much higher wall that can play as the prison next door.

The tables out front are perfect.

First Submission

Now it is ready for submission. Feedback should indicate which concepts to develop and which to drop, so you will now develop them to the next stage. Depending on the complexity of your ideas, it may be worth putting in a section that gives a detailed *synopsis* of how each concept plays out. This should be a prose description of how the video works. Lay out the series of images and sounds that we'll see in your video as if you are watching it in the other room and telling me because I can neither see nor hear it. This will reveal a lot about the pacing, how interest unfolds in different areas, and give a vivid and engaging story. You may want to resubmit the revised synopsis or continue on to the script, but the synopsis is extremely helpful at figuring out exactly how the script should take shape.

Now it's time to write the *script*. Finally. Before we discuss that process, however, we'll discuss the final elements that can appear in the treatment, shot lists and storyboards.

Shot Lists and Storyboards

Not always required, shot lists can be prepared by the initial creative but are likely to be modified by the director. Go through the script and determine all of the perspectives that visually make up the story in the most compelling way. I'll usually read through the script and make notations each time the camera position should change from a wide shot to a close up or reverse shot, then I'll list these out and imagine how the flow works going between each. It's not necessarily an exhaustive list, as at the directing stage this will be revisited, but I'll question whether there is anything else that is worthwhile looking at during that moment to consider options, and then compile these into a list.

Sample Marked Up Script and Shot List

VISUAL	AUDIO
1. CHILDREN throw things across a packed, 4th-grade class.	Children screaming
2. TIM JONES, 10 years old, sits at the back of the class. He ignores 3. the madness and looks pensively out the window to the sunny day outside.	
He speaks to himself.	TIM JONES: "I wish I was grown up already, then I could just be outside all day long."
4. AGATHA, a little girl sitting at the desk in front of him turns around and pushes a book towards him.	AGATHA: "Here. This is for you."
5. TIM looks at the cover. 6. The book is called "Living In The Eye Of The Storm".	TIM JONES: "Huh? What's this for?"
7. AGATHA smiles at TIM.	AGATHA: "I don't know. I saw it in the store and thought of you."
The class door slams and 8. the CHILDREN all freeze, turning their attention to the door. The TEACHER 9. stands, arm folded, scowling just inside the doorway.	Door slam. Children screaming stops.
FADE OUT	

SHOT LIST

Shot Description
1 W/S of children throwing things across a classroom. Cover C/U details.
2 M/S of TIM sitting alone amidst the madness.
3 C/U from outside window on TIM
4 M/S of AGATHA turning around from O/S TIM
5 C/U TIM looks at book cover
6 POV of TIM looking at book cover
7 C/U AGATHA smiles at TIM
8 similar to shot 1 — W/S of children stopping their actions and looking to the door. Cover C/U details.
9 W/S of teacher standing O/S crowd of children. Cover C/U of teacher.

Reviewing the list, it will be obvious that something is wrong if the number of shots doesn't correspond to the duration and pace of the video. A regularly paced

commercial–style video, for example, will have a number of cuts but not one per second, so a shot list of 30 setups may be excessive and 4 setups too little. This obviously depends heavily on the particular job at hand, but it is a good idea to make sure that you try to keep this list to what is really needed to put the script together as you don't want your crew both spending valuable time on unnecessary shots and having less time for the shots that really matter.

Another likely appendix to the treatment is the storyboard, though again this will not necessarily be part of your process. Some companies send the script to a storyboard artist who sends over whatever images they see fit, but I dislike this process as it renders the storyboards a useless indication of what could possibly exist in some parallel dimension. Storyboards should be a useful document that is indicating to the production team (from pre– to post–production) what the sequence of setups should be to comprise the video. They should serve as a tool for guidance in framing and what is important within the frame. This requires the participation of the director — or a creative that is heavily leading the director — otherwise you are misguiding your client and team, and can very easily cause a scenario where the production team is being held accountable to something that was never intended to be used. If you don't need them, don't do them, and if you do them, make it a useful thing.

Finally, I'd try to get a quick look at the document before it goes forward to the client. It may get cherry-picked and different elements dropped into a 200–page PowerPoint deck, where things that are essential to conveying the concepts may get lost. Also, some lovable scamp may try and sneak in a few concepts of their own, which you will ultimately be held accountable to write up.

I've caught this before, when a guy from sales who was working on the deck thought he had some real winner ideas. Turns out they were really misogynistic and dated, not producible with the budgets we were working with, and hardly appropriate for the young women's clothing firm to which we were pitching. Obviously you have to remember your position within the politics of your working environment, but this can hopefully get flagged for the attention of a sympathetic ear and corrected.

10 The Third Pass.
On writing the script.

Your treatment has gone over well and you've been given the go ahead to develop a concept into a script. Congratulations.

First, you need to decide on the script's format. The traditional film script format is less useful than the A/V script, which is two parallel columns that detail the audio and video portions side by side. It can be a bit of a pain to read, as the fantastic linear flow of a regular script is destroyed, but it emphasises what is happening in each area at each moment, so it's actually quite a good format to keep you honest.

> **Regular Script vs. A/V Script**
>
> Here is the same material in both traditional script format and A/V script format.
>
> ```
> INT. CLASSROOM, DAY.
> CHILDREN scream and throw things across a packed, 4th-grade class. TIM
> JONES, 10 years old, sits at the back of the class. He ignores the
> madness and looks pensively out the window to the sunny day outside.
>
> TIM JONES
> I wish I was grown up already, then
> I could just be outside all day long.
> ```
>
VISUAL	AUDIO
> | INT. CLASSROOM, DAY. | |
> | CHILDREN throw things across a packed, 4th-grade class. | Children screaming |
> | TIM JONES, 10 years old, sits at the back of the class. He ignores the madness and looks pensively out the window to the sunny day outside. | |
> | He speaks to himself. | TIM JONES: "I wish I was grown up already, then I could just be outside all day long." |

If you've written out a synopsis, then it should reformat nicely into the script as you've already indicated all of the key action, sound and dialogue. Otherwise, now is the time

to make sure you're conveying all of the key visual and audio elements that convey this concept.

If appropriate, consider the acts or movements within your script. Should it move between an ordered sequence of ideas and progress to a conclusion? How does the subtext relates to the text? Does it break down in a classic format like the following:

Comparison of Subtext vs. Image

Subtext	Image
I was having trouble	Kid struggling with homework
I made a change	A tutor shows up, meets the kid, helps the kid
I'm happier now	The kid smiles as he gets back an A on his test

Breaking the script down into these different movements can help tremendously with clarifying your pacing and story progression. They won't be overtly identified within the script, but their presence will provide a tangible structure and form.

Define every moment in the audio and visual columns that is relevant. If you can, leave nothing to be figured out later. Is there a blurry background under the end GFX? Or do the graphics go full screen on a colour backdrop? Is there space left in the frame for the call to action? Is there music underneath the spot throughout? This stuff needs to be in there to get a feel for the timing and clarify to each department how long something should be on screen, what size, &c. It's far better to flag in the script that a shot will have graphics with an arrow to a certain part of an object in frame — so that the director and camera team frame it in a way that is helpful to the graphics team — rather than have the editor fight with an image that "looks great" but is

entirely inappropriate for the film you're making.

Check your dialogue for say-ability. Does it come off the tongue okay, or is it a tongue twister? Is there some bizarre alliteration? Any damagingly distracting dialogue that deviously diverts from your flow? These things will catch on the ear on set (or worse, in post) and are better cleaned up now. Also, when writing copy that refers to the product, be mindful that the client may have preferred terminology. It may seem like semantics, but it's incredibly important to them and they'll need to show your script to internal colleagues. The wrong use of "shaver" instead of "groomer" can be a massive distraction and result in a distorted view of the work.

Writing a script for non–actors or models means that you should be adjusting the concept to depend as little as possible on a specific reaction or dialogue, and as much as possible on a look or juxtaposition of images. Voice–over is a great way of dealing with any specific messages that need to be conveyed. This strategy also works well if you're dealing with a foreign–language video for which you don't speak the language.

In an interview or voice-over driven video, try to write what b-roll would be appropriate and what it should convey as subtext. Writing "montage" is like putting, "actor says something funny". Not very helpful, is it? But be careful of writing sequences that are too on the nose as they invariably come off as funny, so subtext is best played as an idea that has a common big–picture meaning as the audio but is not literally the same. In a documentary about economics in an African country, I wrote narration explaining how the cost of gasoline is very high in the country. The editor put in a shot of a man pushing his car

that was clearly broken down for other reasons, resulting in an inadvertently funny moment as the edit suggested he couldn't afford gasoline but still wanted to take his car somewhere. The subtext of that shot might more appropriately be "we are a people accustomed to difficulty" and it worked great elsewhere.

After you've written out your first draft of the script, you need to consider the duration. Are you writing to time? If not, don't worry about it. If so, crack out that stopwatch. Read through the script, making your best judgement of which visual elements require extra time to happen or where to skip description and allow for dialogue. Are you at time? Running long or short is okay if you think the script reads correspondingly slow or fast. Generally speaking for commercials or branded content, the last 5–8 seconds will be eaten up by a product or logo shot and messaging, which may by an ugly load of marketing gobbledygook that needs to be reined in, so keep in mind this back end may well end up squeeze time away from the front end.

Scripting After The Fact

Some jobs involve writing a script from pre–existing material that was shot at an event, or maybe a series of interviews. Unless it's a lengthy conference or interview, it's usually better to spend some time putting together a proper written script to identify the flow of the piece than to just sit down and edit without a strategy. The old method of printing out transcriptions, using scissors to cut out sections and grouping them together works beautifully if you have the time and the space. A digital version of this can be done in a word processor with two documents open simultaneously, a working document and a "donor" document. This first pass is just reorganising the material

into logical groups, and then you can select the best bits and do a refinement process.

11

Just Make The Baby An Elephant.
An approach for creative
notes and revisions.

Inevitably, you're going to get revisions that you need to make to the treatment or script. It's important to be collaborative and take on outside ideas — sometimes for the good of the piece and sometimes for the good of your job. The important thing is keep a focus on the core criteria of the treatment and the spine of your concept. Test the new revision against them, and it will fall into one of the following categories. It is critical that you identify which:

1. It is a good or interesting idea and reveals a path to making the concept better.

2. It does not contradict the concept and amounts to a difference of taste.

3. It contradicts the core criteria and reveals that the core criteria is wrong.

4. It contradicts the core criteria and should therefore be dismissed.

5. It contradicts the concept and is generating a new idea/destroying the existing one.

As the creative behind the project, you really need to correctly identify where each note falls and resist the ones that cause damaging changes to your concept, diluting it or taking it off course. These are the most critical ones. They will become obvious at a later stage and fingers will point to you. This means that you need to know your concept to its core, which will inform you as to which elements are critical and which ones aren't and you can pick your battles.

Contradictions to the core idea are worse the later in the

process that they come, and Godspeed in figuring out how to reconcile the situation. Scenarios 2 and 4 can be very frustrating because it can become a game of wills or politics to decide the fate of your concept. If you refuse, you could be alienating your client or colleague and be perceived as someone who is difficult to work with.

If you want to push back on the changes, then you need to be good at defending your work and win this person over with a convincing argument as to why your original way is better, backing it up with things that are good strategy. Is your way "safer" under the circumstances (if that's a good thing for this project) or more likely to come together? Is it a clever reference to something that brings meaning or entertainment? Is it going to be such a great image and will be a big laugh, surprise or emotional moment? Has it been done that way before?

Field Notes

I once wrote a video for a client that was promoting an event to raise money to fight breast cancer. The previous year's video had been sexually charged and arguably exploitative of the female talent in it. It had been created by a female writer/director and talent team, so they were in much safer territory than I would have been, as they were choosing how to be perceived. I was assigned the promo the following year and the client wanted something in a similar vein.

I came up with an idea that featured a series of clichéd porno setups for comic effect, each time suggesting that the man and woman were doing something at the start of the shot but it was soon revealed that he was just helping to fix her car. To contrast against their raunchy behaviour, I had them discussing facts about breast cancer. This

juxtaposition was critical to the idea, because in the end he was just helping her and they were talking about an important issue — the suggestion of porn scenarios was strictly in the mind of the viewer.

The client thought that statistics were boring and insisted that I take them out. This was a horrifying proposition, as it directly betrayed the core tension of the video. Without the contrasting dialogue and humour, this was just going to be a mock porno, which was a crazy proposition for me — having a laugh at porn in support of breast cancer seams to suggest that there is some sort of link between them, or unduly and bizarrely sexualises a serious disease, without any value coming from this association. I only supported this scenario by its juxtaposition to factual information, that mimicked the unwieldy dialogue of the style but, in contrast, had information of great value.

Thankfully, I was able to express to the client how critical this element was to the structure of the video and won the day. Failing that, I would have insisted on restarting with a new concept that accepted this new core criteria — the mandatory that no statistics were used.

There may be multiple rounds of revisions, but once that final revision is done, your treatment and script should be complete. It's a contract and it's now out of your hands. Forget about it and enjoy/be tortured by the down time until the next one.

A client may insist on changes on set in the middle of the production. In most cases, whenever a detailed script has been prepared in advance (rather than a rough guide due to the unpredictable nature of the production), it is

unwise to make significant changes in the moment unless circumstances demand it. Your plans are geared towards a certain blueprint, and while changes may seem easy to accommodate on set, you are now making changes without due process of consideration. These may unravel the concept, cause contradictions or create holes that require other additional footage to reconcile, and the danger is that you won't see these in the moment and won't shoot them. I consider this a quite different scenario from a genuine problem occurring and trying your best to find a solution, because then you have no choice but to make the change for the good of the production.

Handling revisions can be a tricky path to navigate, and it is important to set aside your ego to examine each one for the objective value that it contains. I generally accept that a comment is a genuine reaction to something that may be unclear or unsuccessful with the work, but don't take the proposed solution with the same value unless the person submitting the comment is educated in our field. I can't argue that you don't find a video compelling, for example, but I can dispute that your solution to put voice-over and a logo throughout it are the best way of rectifying the situation, much in the same way that I go to a doctor to deal with a rash but don't tell them the best way to deal with it because I am appealing to their expertise.

Late Changes
Ideally, a project progresses from one stage to the next when the details are approved. Changes to any one area can result in everything that comes afterwards to be thrown into question, which can invalidate the approvals and result in costly delays. This resets the project to that stage and all subsequent details should be reconsidered.

In the real world, some of these stages will occur concurrently due to lack of time and the producer will take a calculated risk to manage the job. Major changes can then be immensely tricky to accommodate as they can trigger a return to a previous unapproved state with all of the related knock–on effect to the project. A key change to the script, for example, could require a rethink of the concept, which affects the script, budget, production planning, bookings, timelines, and any number of things.

The Impact of Revisions to the Stages of a Project

Brief → Treatment → Script → Production Planning → Production → Delivery

A change to a key piece of information in the brief that occurs at the Production Planning stage can mean that the treatment and script are no longer valid. Carrying on without considering these implications can prove disastrous.

It is important that the creative and producer cooperate to ensure that any revisions are discussed together to determine any possible ramifications, rather than either one confirming that they can be done. The producer promising a change that will compromise the creative is just as bad as the creative promising one that has a planning or budgetary impact.

12

You Are There.
A conclusion to our discussion.

Writing for short format video can be challenging and rewarding work, and there is no doubt that this is a growing area with increased demand year on year. It's amazing how much good writing benefits from knowledge in all of the other areas of production, whether it's directing, producing, cinematography, production design, editing, graphic design, animation, sound design or compositing. Each one offers tremendous insight into that area that allows a sophistication in your writing, but also helps you to write effectively both for that area and for budget, as you'll have a good sense of how many days something will take, how costly, or possible visual effects techniques for getting a shot that seems complicated on paper. Knowledge about animation, for example, will let you write a proposal that explores styles with confidence, and you can even submit an animatic or test to demonstrate your concept.

I would encourage you to stick to it and develop your own version of the process. I'm constantly modulating how I work, but enjoy the confidence that I've got my method, and that it's flexible enough to withstand variance but reliable enough to be depended upon.

& Holding Hands With Mr Happy.
A final note to clients from creatives
outlining a method to work together.

Hello, friendly client!

It is really great that we're going to work together and create the video that you need. I am very committed to doing my best quality work and thought I should lay out a few notes that might help me to help you during this process.

It's really important that I get a brief that covers off a few things — the purpose of the film, the target audience, the tone, anything that must (or must not) be in the video, how it will be distributed, the versions that you'll require, important dates and the budget. Some of these may not seem critical at this point, but I assure you that each one can have important implications and I will take them careful consideration as I come up with your custom creative ideas. You can either send this information over to me in a document or we can have a conversation and I'll write it all down, just let me know what works best for you.

Next, I'll send you back a treatment that gathers some of the information from your brief and presents a few creative concepts that answer the brief. Please double check that I have not misunderstood any of the items from the brief, because it's possible that my interpretation of what you are asking for has deviated off the mark of what you are really after. The concepts that I'm putting forward will explain a little bit of what each will look like and how it will work to answer the brief. Please consider how well they address the objective and whether you agree that this is what your audience will respond to. Let me know which concept works best, and I'll develop it into a synopsis and script.

I'll resubmit the treatment to you, but this will have the rejected concepts stripped out and the remaining one(s)

developed a bit further. The synopsis is longer than the concept, and walks you through the video as if you are seeing it. The script puts the synopsis into a standardised format with the visual elements noted on the left and the audio elements noted on the right. This parallel format is designed to help you keep track of what exactly is happening at each moment, and to be able to quickly pull out the audio messaging for review.

Please read the script in detail, as it is all very critical at this point. It's okay if you find it difficult to read or to follow exactly what's going on. You don't read this format every day, do you? I'm happy to go over it with you in person or on the phone to help bring it to life. As we go through it, keep in mind that if it's not written here, it won't be shot. Is the text accurate? Do we need extra graphics somewhere? Is there any legal copy or logos that aren't mentioned?

This is the moment to get everyone who has an important say on your end to approve it. It's critical that changes are made at this point before we get into pre-production, as small changes in the script can mean huge changes to the planning process and we want to make sure that money is spent as effectively as possible.

As we go through this process together, you will definitely have comments or concerns and it is our job to address them clearly. Ideally, it will be easy to accommodate the revisions that you would like. I accept that your comments will reflect something that isn't working or has missed the mark, and I will take these notes seriously. But I hope that you understand that sometimes I will need to reject the solutions that you may propose, as they may not be the most effective way of addressing what

it is that needs changing, and in fact cause other ramifications that we don't want. The experience of something feeling long, for example, isn't necessarily fixed by cutting it down — it may be that the order of shots is wrong or some information comes too early or too late, causing the *feeling* of it being long because the pacing of engaging the viewer's interest is off. Please allow me to try a few alterations and we'll see if that solves the problem.

Similarly, sending the work around to multiple people for feedback isn't necessarily a good thing. I understand that it can be difficult to gauge if it is working, but we are in this together and it is our job to guide you through the process. This approach is effectively working by committee, and again I would suggest that listening to people's emotional reactions can be helpful to us but let's shy away from their prescribed solutions.

That's about it. I look forward to listening closely to you and giving you my best work. I really hope that we have a fantastic experience together and you feel proud of the job when we're done.

All the best,

Your Creative

About The Author.

Karim Zouak is an award–winning writer, director and producer that has been in the business for almost 20 years. Working in both Canada and the United Kingdom, he has honed his craft as writer, director, supervising producer, editor and visual effects artist on commercials, television series, feature films and countless online videos for clients like MTV, Channel 4, Nike, Sony, Philips, Virgin, Blackberry, Unilever and Diageo.

His work has been produced and seen internationally in multiple languages by millions of regular viewers, and developing strong creative work remains the heart of his dedication to the craft.

In addition to this book, Karim actively discusses and develops his ideas on creative process and technique on the "Short Ideas" blog, located at ShortIdeasBlog.com.

Printed in Great Britain
by Amazon